MOMENTS that MATTER

Real Life Photography Techniques for Capturing the Wonder of Family Life

FARRAH BRANIFF

Introduction by
BRENÉ BROWN

bright sky press

HOUSTON, TEXAS

for Sayer, Finnian and Einin
My little soulmates, loving you taught me what it means to love with my whole heart.

for Steven
My partner in the trenches *and* the triumphs...thank you for being mine,
standing by me and loving me.

for my parents
For putting that first camera into my hands, for sending me to art school, for letting me roam and be
free and cheering me along even when you think my decisions are crazy.

for Rhett
Thank you for never minding all the pictures I took of you and
for being by my side for so many amazing adventures.

for Brené
Truly, without your encouragement and help, this book would not exist.
I am so grateful to you for believing in me, even when I didn't.

for Samantha
I know that you walk with me wherever I go.

 bright sky press
HOUSTON, TEXAS

2365 Rice Blvd., Suite 202
Houston, Texas 77005

10 9 8 7 6 5 4 3 2 1

Library of Congress Cataloging-in-Publication Data

Braniff, Farrah.
Moments that matter : real life photography techniques for capturing the wonder of family life / Farrah Braniff.
pages cm
ISBN 978-1-936474-93-6 (pbk.)
1. Portrait photography—Popular works. 2. Photography—Technique—Popular works.
3. Children—Portraits—Popular works. 4. Travel photography—Popular works. I. Title.

TR575.B755 2013
778.9'25--dc23 2012033679

Editorial Direction, Lucy Herring Chambers
Creative Direction, Ellen Peeples Cregan
Design, Marla Y. Garcia

Printed in Canada through Friesens

NOVEMBER 2013

MY CAMERA IS SO CONFUSING!

HOW DO I CAPTURE MY KID'S TRUE EXPRESSIONS?

WHY ARE ALL MY PICTURES YELLOW AND BLURRY?!

MY CAMERA MANUAL IS OVERWHELMING!

I SEE THE PICTURE IN MY MIND BUT I CAN'T SEEM TO CAPTURE IT.

WHAT DO ALL THESE BUTTONS MEAN?!

I'M AFRAID TO TAKE MY CAMERA OFF AUTO!

I HAVE A BIG, FANCY CAMERA AND NO IDEA HOW TO USE IT.

I HEAR THESE ISSUES all the time in my photography workshops. As parents, we want photographs that show the magic, the love and the story of our families. We have all this amazing technology at our fingertips, and people have told me that their photographs are worse now than when they used older, less sophisticated cameras.

Help is here! I will answer your questions, share my secret tips and walk you through the process of becoming a better photographer. I'm going to teach you simple but powerful techniques that will transform the way you imagine and take photographs.

Yes, your camera manual is scary, and you just can't bring yourself to read it. I get that. This book is not that manual.

The journey begins now. All you need to get started is a camera and a child that you love. It's a new day, friends. Charge up those batteries, because we've got some fun work ahead of us!

Tanah

Table OF Contents

Introduction

1. "I'm not very creative" doesn't work. There's no such thing as creative people and non-creative people. There are only people who use their creativity and people who don't.
2. The only unique contribution that we will ever make in this world will be born of our creativity.
3. If we want to make meaning, we need to make art.

If these findings hadn't emerged from my own research, I wouldn't have believed them. I spent my entire adult life being "too busy/strong/arming the to-do list" for creativity, art or crafts. So, when I found that creativity is key to wholehearted living, I was inspired to make a change. I wanted to become a photographer.

There was only one problem. I'd forgotten how to be new at something. I forgot about that awkward, uncomfortable process that defines the gap between wanting to take pictures like the ones I see in the magazines and having no idea how to use my camera or set up a shot.

Then I met Farrah. My husband actually set me up with her on a friend date. He's her kids' pediatrician and, truthfully, I think he thought we shared the same work/balance anxiety so he recommended we meet for lunch. When I told her about my new foray into photography she offered to take on the challenge of teaching a not-good-at-being-new, creativity-fearful and want-everything-to-be-perfect budding photographer.

Farrah changed my life. Not only is she a gifted artist, she has a long teaching history *and* she's a trained counselor. She can nail every part of the technical challenges, teach in way that makes it crystal clear and talk you through the frustration and vulnerability that is the joy (and struggle) of making art.

I wanted to take pictures of my children, my extended family and the ordinary moments of my everyday life. I showed her both my favorite pictures from magazines and the pictures that I had taken over the years. She taught me composition by pointing out the differences between the photos I loved and the ones that didn't quite reflect what I was trying to capture.

She taught me about complicated issues like aperture and light by making me practice with my son's Transformers and shooting thousands of pictures next to every window in my house (and I'm not exaggerating). One of my favorite teaching moments happened one day when I was trying my new macro lens and I couldn't get anything to work right. I called her, and she said, "Go into your front yard, get on our stomach, aim your camera at the caterpillar on the leaf and turn on your camera."

I said, "Okay, I'll call you back and let you know how it goes."

She said, "Nope, you're taking me with you. I'm staying on the phone."

I'll never forget army-crawling through my flowerbed with my phone in one hand and my camera in the other.

Dive into this book. Start anywhere. Take thousands of shots. Screw most of them up. Then find that one that tells the real story. No one can walk you through it like Farrah. She has the photography, teaching and hand-holding skills to help us capture the moments that matter.

BRENÉ BROWN
Author of New York Times #1 Bestseller *Daring Greatly: How the Courage to Be Vulnerable Transforms the Way We Live, Love, Parent, and Lead*

MY Photo Life

Photography and I met when I was in the ninth grade, and it was pretty much love at first sight. An artist from an early age, I went to a fine arts high school and then continued on to study fine art photography in college. Through college and then graduate school (and all the random jobs in between), I always had my camera at my side. It wasn't until later that I would figure out how to make a living using my camera. Thankfully, I did. My husband and three children have been instrumental in helping me find my way. They inspire me in a way that's hard to put into words. They opened up my heart, which in turn opened up my eyes to see life in an entirely new light. They have helped me understand that being a million and one things is perfectly okay. In fact, it's what makes me uniquely me. So, just to name a few, I am a Mom, photographer, wife, teacher, writer, blogger, fan of punk rock *and* country music, collector of impractical shoes, traveler, tattoo lover and loyal friend who loves to go two-stepping with her husband. On these pages is a patchwork of me. This is a little bit of my story, my photo life.

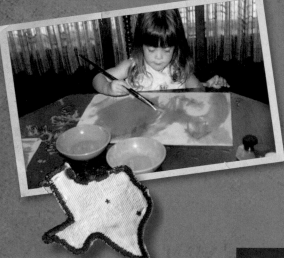

1985
THE LITTLE CANON CAMERA THAT CHANGED THE COURSE OF MY LIFE.

1984
THE HIGH SCHOOL FOR THE PERFORMING AND VISUAL ARTS. MY FIRST PHOTOGRAPHY CLASS.

2005 & 2011
I BECAME A MOM FOR THE
SECOND AND THIRD TIME.

2003
MY PHOTOGRAPHY
BUSINESS IS BORN.

2003
I BECOME A MOM
FOR THE FIRST TIME.

1991
ART COLLEGE IN
SAN FRANCISCO!

2013

CHAPTER 1
Telling a Story

Growing up, my Dad was our family photographer. It's usually like that in families: one person is the main photographer and memory chaser. My Dad chased down our memories well, and I'm grateful for it. I can open any of his scores of albums and peek into my history. While I can say that my Dad was a great photographer, these pictures are not professional shots. They were not captured with fancy equipment or shot in a studio. They're on the beach or at birthday parties. They are of us playing dress-up and posing in our school uniforms on the first day of kindergarten. They are tiny, everyday moments that, when strung together, tell the story of our family.

There's no way any of us can remember it all, and that's where our photographs take center stage. They remind us of friends and relatives long lost, houses we grew up in, haircuts we should never repeat, personal victories and world travels. When we look through them, we appreciate the emotional content the most. So, the question becomes *how do I do that better? How do I tell the story in a way that will bring me back to this specific moment in time and allow me to relive how it felt, even just for a second?*

Keep in mind, the story is different for everyone. Your most heartfelt images may not speak to me as they do to you, and vice versa. You were there, and I wasn't. Don't worry too much about

whether or not your images will speak to a stranger; think only about how to make them speak to you and the people in them. That's who matters the most.

Whatever you do, please try not to get discouraged as you practice. Photograph as you would practice if you were taking piano lessons. Pick up your camera often, and know that, with each shot, you get a bit better. Your fingers become more nimble at the controls and your eye learns to see the story more clearly. Don't fret about missed opportunities or mishaps; not even the pros get the shot every time. The biggest thing to remember is that your family will cherish any part of the story you tell.

More than just a good laugh or a sweet memory, the photographs you are taking today are the ones that will chronicle the history of your family. They will tell the story of who you are and what the journey was like along the way. I am going to help you create images that stir up beautiful memories, make you laugh and capture the spirit of your family. I want your children to look at their family albums and know that they were dearly loved.

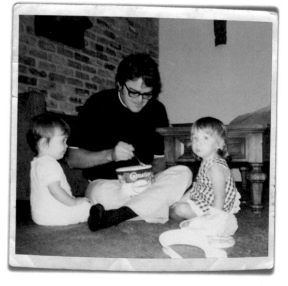

Summers at the bay house and Granny's month long birthdays live on in my mind and in the photos even though both Granny and the bay house are no longer with us.

I still eat vanilla ice cream right out of the tub, and it always makes me think of my Dad.

THE ANATOMY OF A STORY

What makes up a story, and how do you go about telling one in pictures? I believe that the story is made up of a few distinct elements: the emotion, the action, the location and the details.

Let's start with my favorite part, the **emotion**. This is the expression, the laughter, the twinkle in their eyes and the connection between people. This part of the story is by far the most important when it comes to photographing our children. Their true smiles can be hard to capture, but you can do it. I'll show you how.

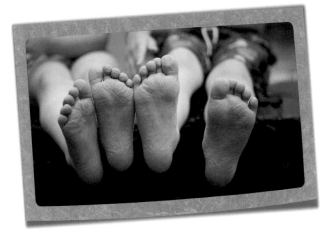

Little wrinkly toes tell the story of hours spent in the pool.

ANATOMY
OF A STORY

- Emotion
- Action
- Location
- Details

The next part of the story is the **action**. What's happening? Is it a game or recital? Is someone dancing, singing, jumping, rolling? Learning how to stop action in a photograph is also something that we'll cover. I'll teach you how to intentionally make something blurred (to show movement) or to freeze the motion as it is happening.

What about your **location** or setting? Are you standing in front of the Grand Canyon? Is your child looking out over a beautiful lake? If the setting is a part of the story then we want to include it. If it's not, there are ways to minimize it to allow the more important parts of the story to shine through. We'll cover this when we get to depth of field.

Don't forget your **details!** The details are the small elements that add to your story. These could be close-ups of the parts of a face, tiny fingers and toes or the swirl of a newborn's hair. The details could also be a part of the location—like a ticket stub or an architectural element. Maybe it's the long drips streaming down your toddler's arms as she eats her ice cream cone or the way your high schooler doodles all over his class notebook.

Emotion

What are you feeling? How can you make the image show the viewer how you felt? Can you photograph the scene in a way that helps her feel it too?

Location

Are you somewhere special? Do you need to show the wider scene to really tell the whole story? Does the background need to be in focus or should it be blurred?

Action

What is happening? Is it something that requires you to capture motion by freezing or blurring it?

Details

What small details can you capture? These little things add extra dimension to your story. They might be part of your location, a tiny physical detail or something little and quirky that speaks volumes.

One of the biggest things that can ruin an otherwise great image is distracting background or foreground elements that add nothing to the story being told. In general, unless it is a story of excess (the aftermath of your three-year-old's birthday party), less is almost always more. It usually goes something like this: your child has this amazing expression, the light is perfect, her outfit is just right and, because of where she is sitting, there is a tree that appears to be growing out of her head. We'll get to this sort of problem as well when we start to look at cropping and framing and how they factor into your storytelling.

What I want you to start doing now is being mindful when you are photographing. One of the best ways to practice this is to just start watching. As you watch your children playing, you can imagine that you are photographing the scene. What would you include and why? Are there any elements that are distracting? How could you remove them? Another good place to start is by looking at the photographs that you love and asking yourself *Why? What is it about the image that I love?* Is it a feeling or is something in the image? Do the elements that I love have to do with emotion, action, location or detail?

Vacations are a great opportunity to experiment with storytelling. Most of us focus on getting the smiling picture in front of wherever it is that we're going. I challenge you to shoot instead as if you were writing a book. If you were writing a book about your trip to the beach, you'd be describing the beachside café where the kids fed the seagulls and the way their little toes looked all covered in sand. You might tell us how beautiful the sunset was and how your eighteen-month-old kept eating the sand and smashing his sister's sandcastle. These are the pictures that I want you to take. These are the images that will make you remember it just like it was yesterday.

THE LOCATION

A Day at the Beach
El Capitan, CA.
2012

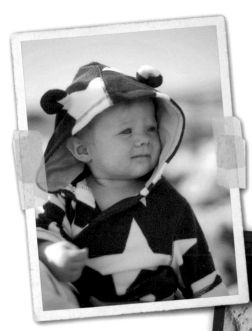

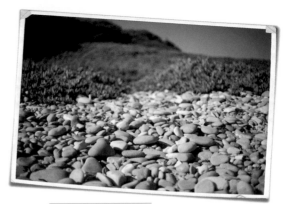

Central California
textures and colors.

Closer up, her very first
view of the ocean.

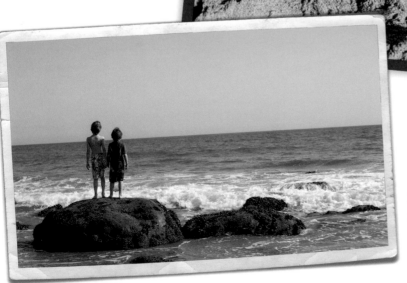

Details, first toes in
the sand!

Taking it all in.
Little boys in a big
landscape.

BIG STORY

The location is critical!

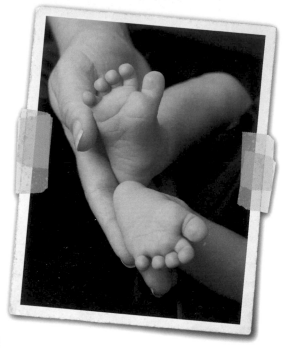

LITTLE STORY

Zoom in and keep it simple.

Be mindful when you shoot. Imagine that your images are little treasures: when you hunt for them, you have to be patient and look carefully.

HOW TO PRACTICE

One of the most intimidating things about photography today is how advanced and complicated cameras have become. Most people have no idea what all the icons, buttons, switches, beeps and menu options mean. And the manual? It's really unrealistic to assume that someone who hasn't taken a basic photography class would feel comfortable reading through a camera manual. However, by the time you finish reading this book, I know you'll feel confident, empowered and no longer afraid of the manual.

I know that as you read, you'll want to jump ahead and skip around. Try to resist! Each chapter builds upon the one before it. Following some of the more detailed how-to sections, you'll see a section like this one called "How To Practice." This is where I'll suggest exercises for you and give you tips before you start.

- **Go to *www.farrahbraniff.com* as you read and check out how-to videos, tips and more.**

- **Your new photography journey begins today. Go slow, be patient.**

- **If you feel frustrated, it means you are doing it right. Keep going.**

- **In the beginning, photograph outside so you have plenty of light.**

CHAPTER 2
About Equipment 2

R epeat this mantra: *The camera isn't taking the picture, I am*. You can have the world's best camera and take terrible pictures, and vice versa. What I see most often when people get a new camera with lots of features and controls is that they get intimidated and put it on auto. It then stays on auto for the most part, because whenever they venture away from it the pictures don't turn out, and they feel frustrated.

Equipment *does* matter, but equipment alone will not improve your images. You have to take charge and learn how to use your equipment before you will see the real changes you want. What we're going to do is start simple. We're going to take it step-by-step, and before you know it you'll be amazing yourself with your new and improved images.

POINT AND SHOOT OR DSLR?

There are two basic types of digital cameras, the point-and-shoot and the DSLR. An SLR camera is one that allows you to change the lens. The D in DSLR stands for digital. Some DSLRs come with a built-in flash, but you can also add an external flash for more power and control. DSLRs offer greater flexibility, more features and a quicker "click" (little or no annoying shutter delay when you snap the picture). If you are serious about taking better photographs, I highly recommend that you look into purchasing a DSLR. Your point-and-shoot is a great tool when you need a pocket camera, but to expand your skills and improve your images you will also want to have a DSLR.

Every busy family needs a point-and-shoot. There will be many times that you won't be able to bring your bulkier, more expensive DSLR along. For instance, any parent who has enjoyed a ride down Thunder Mountain at Disney knows that you need a camera that slips into a Ziploc bag. When using your point-and-shoot cameras, you need to understand and accept their limitations. In exchange for portability, they tend to have few features, more automation and annoying shutter delay. Point-and-shoot cameras are getting better. Many of them now offer "creative modes," or semi-automatic modes like the DSLRs have, which allow you to have more control over your image making. Once you've worked through these lessons and expanded your knowledge and skills, you'll have a much better idea of what to look for in a good point-and-shoot. Keep in mind that some story is better than no story. So, when the situation calls for portable gear, grab your point-and-shoot and go!

I like to travel light when it comes to equipment. If I am taking pictures of my children, I generally use my DSLR, one lens and very occasionally my flash. I also have a small point-and-shoot that I love. Too much equipment, fragile equipment or equipment that you don't understand will make you preoccupied and worried. The last thing you want is to be so busy managing equipment and trying to capture the story that you aren't a part of it.

CHAPTER 3
Getting Closer 3

The best images grab you. They tell a story right away, pull you in and have a clear subject or message. The main problem most amateur photographers have is that they shoot from too far away from the subject. The distance makes the photographs cluttered and hard to "read."

This first shooting exercise is easy: You simply have to get closer. One of the reasons getting closer is so helpful is that it directs the viewer's attention to the subject, eliminates distracting background elements and makes an image more intimate and engaging. This is especially true of portraits.

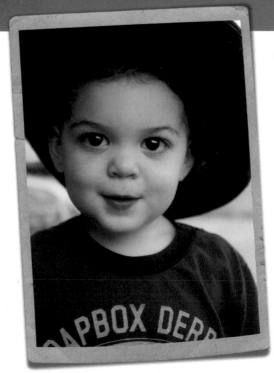

When you get closer, I want you to fill the frame with the central subject; allow it to take up as much space in the photograph as possible. A bonus for getting closer is that the background will often be out of focus, which adds more emphasis to the subject.

When you begin to compose your image in the viewfinder, go back to the earlier question *what is the story that am I trying to tell?* As you experiment with your cropping and framing, you may find that not all stories require whole bodies or big scenes. If the story is about the tiny little fingers of a newborn, that story is very small. Keep it so by zooming in and including only what you really need to show. If you take a trip to France, the White House or Disneyland, your story may need to include the larger background to show where you are. In this case, zoom out or back up and include the elements that you need.

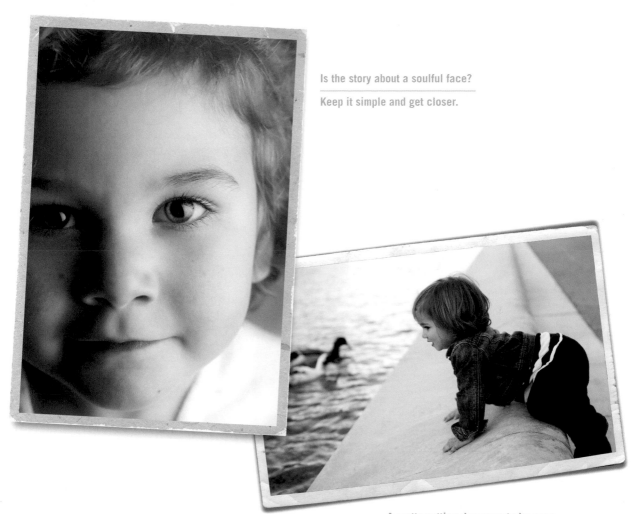

Is the story about a soulful face?

Keep it simple and get closer.

A pretty setting deserves to be seen.

Back up and include it.

CLOSE UP TIP How close you can be to your subject while still achieving sharp focus is different with every lens. Test your equipment by seeing how near you can get and keep your subject in focus. You need to know this information about your equipment. Often, your camera will alert you with a beep or blink that confirms focus is set or not allow the picture to be taken if you are too close.

You can find a good background almost anywhere. The trick is only including the pretty part and cropping or framing out the distracting parts. Don't panic if your yard is imperfect! Just find a small spot with some pretty light and get closer. What does "pretty light" mean? We'll get to that when we learn about shooting outdoors.

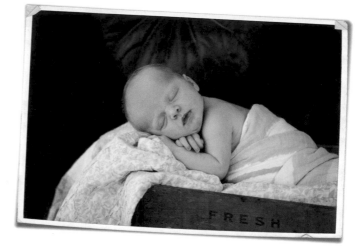

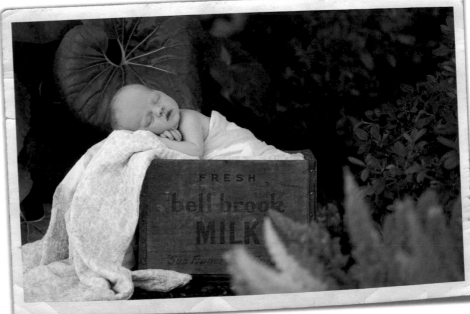

Busy and cluttered? No problem!

Look for some nice light and get closer.

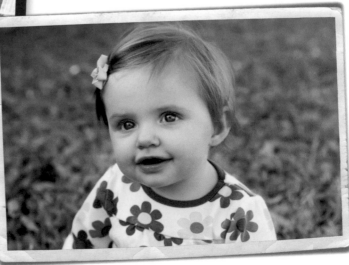

Lack of landscaping? Winter grass?

Get lower and closer and let the face take the focus away from the background.

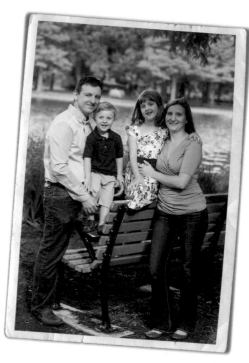

Getting closer gives the photograph a more defined subject and clearer message, and it helps it have more impact as well. When your subject is competing with a busy background or foreground, it's hard for viewers to know what they are supposed to be looking at.

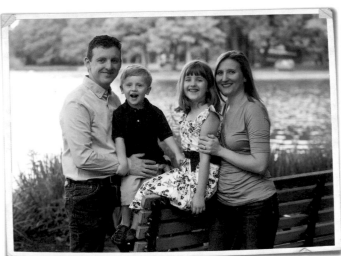

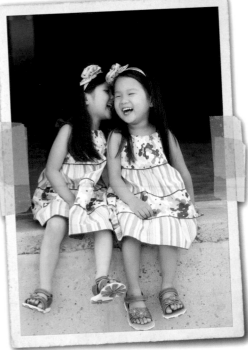

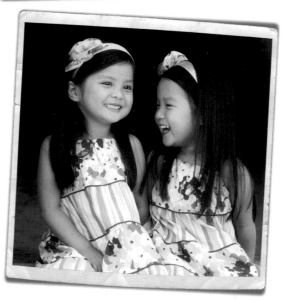

Focus on what's important

In these images, it's the faces.

The key to a great shot is finding good light and making sure you only include what you need to tell your story. If the story is about her face, then find a spot where you can zoom in and crop out the distractions. In the first picture, we can hardly see her face, and there are so many distractions. Look at the difference when we zoom in and make the photo just about her and her expression. So much better!

HOW TO PRACTICE

Find a willing model (your toddler doesn't count). An older child may be able to sit for ten to fifteen minutes while you work on this exercise. Having your model look at you and smile is less important than just getting a feel for getting closer and the way it affects your images.

- Pose your model, preferably outdoors and in the shade.

- Take a picture of his entire body and then move in incrementally, taking pictures at various distances until you have a close-up of only his face or even just a part of it.

- When you are done, look at your set of images and see which ones you prefer. Note how the feeling of the images changes as your distance changed.

- Experiment with backgrounds like the example pictures in this chapter. Can you find a pretty background where you are by cropping out distracting elements?

- Go through pictures that you have already taken. Can you improve them by cropping in closer to your subject or by eliminating distractions?

MACRO LENSES

SOME CAMERAS AND LENSES won't focus closer than about twelve to eighteen inches. Check your camera and see how close you can be and still keep your images in focus. Some cameras and lenses have a different setting for getting really close, and some are specifically made to get close. Lenses that are made to focus at very short distances are called macro lenses.

One of my favorite lenses is a Canon 50mm compact macro lens. This lens allows you to get up close and personal with your subject. Your current lens may also have macro focusing capabilities. One of the best ways to determine this is to take time and experiment *before* you need to capture an important moment.

Looking for pristine, sharp focus?

Using a macro lens allows you to catch all the glorious detail of babyhood.

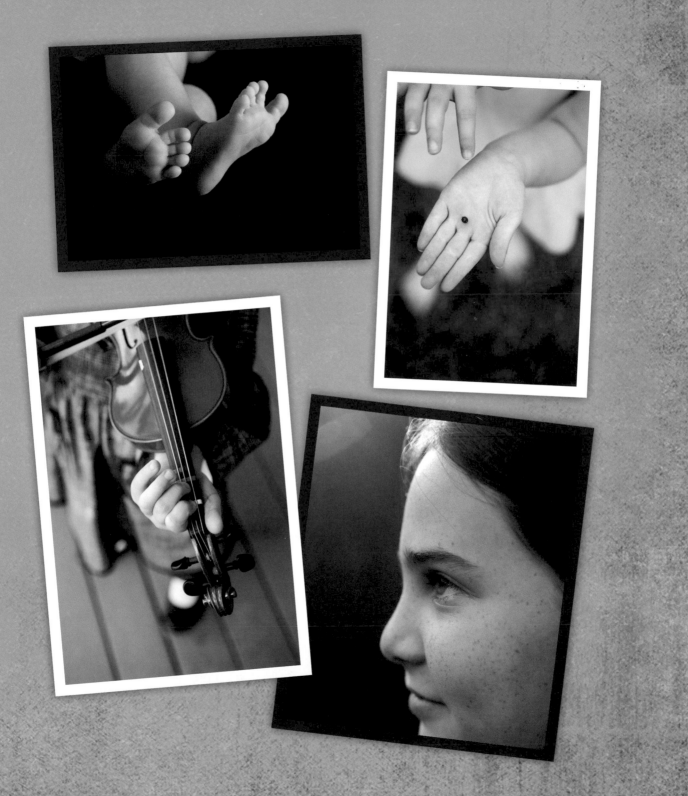

CHAPTER 4
Learning *to* See 4

"THE CAMERA IS AN INSTRUMENT THAT TEACHES PEOPLE HOW TO SEE WITHOUT A CAMERA." – Dorothea Lange

The more time you spend looking through your lens, the more the way you look at the world will change. You'll start to notice that cool shadow creeping up the wall or the reflections in the puddles on the sidewalk. You'll see lines and angles in the walls, roads, buildings and landscapes around you. Slowly but surely, your images will become less cluttered. All it takes is mindful practice and lots of shooting.

In this chapter, we're going to go over some visual tips and tricks that will train your eye to see the world around you in entirely new ways. I want you to become obsessed. Look at everything around you and ask yourself how you would photograph it. I want you to begin to notice the tiniest details, textures, colors and the beautiful way that light illuminates the world around you. Before long, you'll find yourself frozen in your tracks, looking at the way a long shadow stretches beautifully across empty pavement or the way sunlight streams through the window and skims across your child's face. It will make me deliriously happy to hear that you've become an avid smartphone-ographer simply because you now see all this crazy beautiful detail that you might have passed by before and you can't resist trying to catch it while you can.

NATURAL FRAMING

Natural framing is done by utilizing the existing structure in your scene to frame your subject. Find windows, shapes in the landscape, doorways, gates and anything else that helps add a visual frame around your subject. This technique isolates your subject and makes it very clear who or what is the intended "center" of your photograph.

LEADING LINES

Leading lines make use of the existing lines and angles in the scene to help bring the viewer's eye right to your subject. Look for things like the line or curve of a path or the elements in the surrounding architecture or landscape. Try placing your subject along one of these lines and see how it helps pull your eye right to the center of interest.

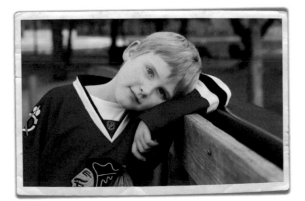

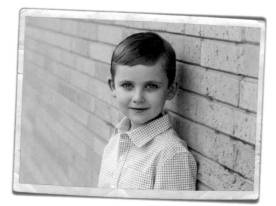

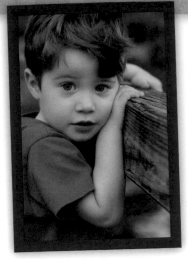

GET LOWER

When you are photographing small children, don't forget to come down to their level for some shots. When you do this, you create a natural, eye-level look for your viewer. It also allows you to engage the subject for better expressions and good eye contact.

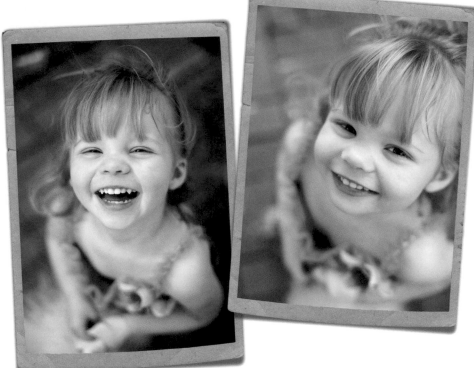

EXPLORE ANGLES

Don't be still while you're shooting. Move around, up, down, on an angle, to the side and now to the other side. Sometimes when shooting, a simple movement in any one direction makes the image so much better. Try every shot a couple of different ways and see what you discover.

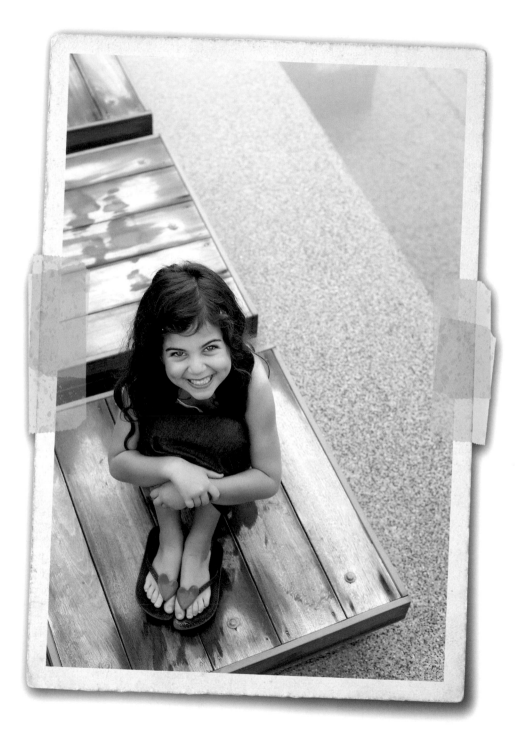

RULE OF THIRDS

One of the most popular concepts in photography is the rule of thirds, though it isn't generally mentioned in your camera manual. The rule of thirds is a visual exercise. It helps you be more purposeful about your cropping and framing and helps teach you how to see your images in a new way.

The basic idea of the rule of thirds is to imagine breaking your image down into thirds horizontally and vertically so that you have nine parts, like this:

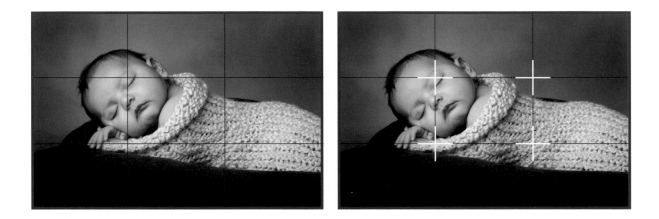

The intersections of these lines give you four important spots to consider placing points of interest as you compose your shot. This placement helps the viewer visually, and the shot feels more purposeful. People are naturally drawn to these areas of the image. It's easier on the eye. When you align critical elements in your photograph with these points you create more tension, energy and interest in the composition than if you had just centered the subject.

This doesn't mean that you never put anything in the center. Sometimes the center is the best and most logical place. You'll have to make that decision as you photograph, maybe even doing it both ways to see which one turns out better. Consider this: a great image is often one that breaks the rules. I know you've heard this before but it's true in photography, too: You have to learn the rule first before you can break it.

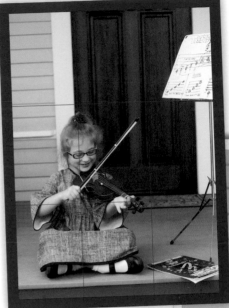

Adobe Photoshop® and Photoshop Elements® have this grid as part of the cropping tool. It's something that you can turn on in your preferences if you like. iPhoto® has this feature as well. While it's nice to have this feature available in your software, you can experiment with this technique simply by imagining the lines and trying to place important elements off-center.

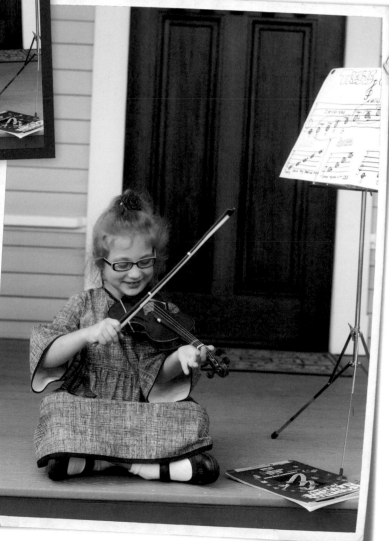

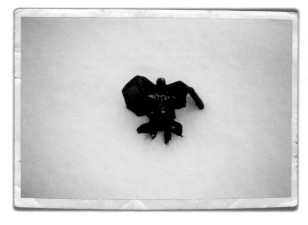

Here's a shot of one of my family's favorite villains, Darth Vader, posing with a flowing cape on a snowy hillside. I placed the rule of thirds lines over the image so you can see the intersections.

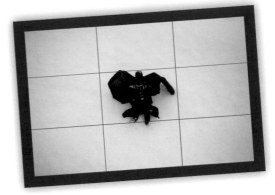

I love the way the rule of thirds can take something simple like our villain here and make it feel more artistic and interesting simply by its placement. Another reason why the rule of thirds makes an image more dynamic is that it helps utilize the negative space (or background) in the image to give it a more interesting shape. Often that shape can add interest or help direct the viewer's eye to the main subject.

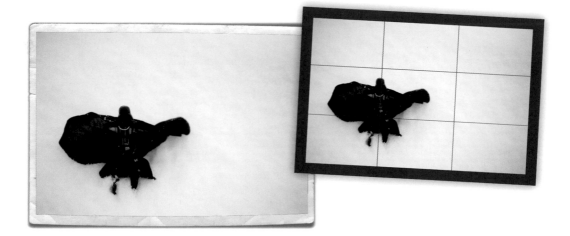

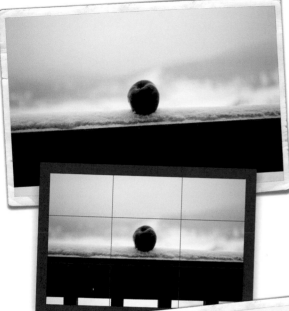

Here's another example of how changing the positioning of the subject (or yourself in relation to it) can really add new depth and interest to your image. Notice how I am experimenting with an object and not a child? When you are learning a new technique it is always better to start with something that will remain still.

In the first image, the apple is centered. In the next image, I used both the rule of thirds *and* leading lines to create depth and a more interesting composition.

Symmetry does works nicely in certain images and not all images need to be off-center. You can have symmetry and use the rule of thirds too. Just play with the key intersection points and see how it changes the way you photograph.

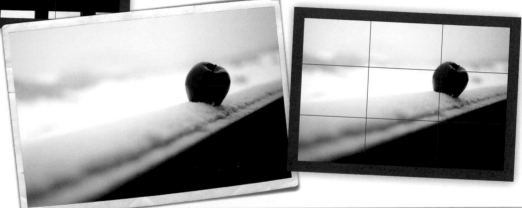

BE CAREFUL! Watch out for your camera's auto focus feature when playing with off-center framing. Most digital cameras are designed to focus on the center of an image. Try this:

1. Temporarily center your subject and focus using the camera's auto focus.
2. Keep holding down the shutter release button and recompose your image. This will usually hold your focus where it was.
3. Now take your picture.

PRACTICE EVERYWHERE

Practice with your smartphone. Practice with your eyes as you look at the world around you. Use your vacations as inspiration. Photograph subjects other than people and try out your newfound compositional skills. Photograph everyday objects. Before you know it, the way you see the world will begin to change.

HOW TO PRACTICE

- Use simple household items (like the apple) to play with leading lines, various angles and the rule of thirds.

- Take your camera outside and photograph your backyard or shoot around your house. Look for lines, textures, colors, angles and patterns. Can you take regular everyday objects and make them look unique and different just by the way you photograph them?

- Take your existing pictures and crop them in new ways, experimenting with the rule of thirds. Certain photo software (like iPhoto®, for example) allows you to turn on a rule of thirds grid when you use the cropping tool.

- Take one picture fifteen different ways and try for something different each time.

- As you go through your daily life, even when you don't have your camera, mentally take pictures. Turn your eyes on and practice seeing.

- Make use of your smartphone and take a few shots everyday. Seeing takes practice, and daily exercise makes a huge difference.

SHOOT MORE!

ONE OF THE JOYS OF DIGITAL PHOTOGRAPHY is that we can shoot to our heart's content without stopping every twenty-four or thirty-six shots to change a roll of film. Some of the best moments are caught accidentally just by being in the right place at the right time. Don't second guess, just push the shutter button and then do it again, and again.

Buy big enough memory cards so you can shoot without worrying about space. But, don't be afraid to delete pictures that you don't like. If you dislike an image later, you can delete it. I give you permission to get rid of images, even if they are of your child. The key is to be realistic about the sheer number of images you will end up with as your children grow. There is no reason to keep the blinking ones, the blurry ones, the way-too-dark ones or any of the other mishaps. Repeat this mantra: Shoot more, delete more, end up with more quality. Like the old adage says, practice makes perfect. The more you shoot, the more comfortable you will be with your camera and the better your images will be.

Some of our shots are just quick snapshots. We get one or two and move on because the moment came and went and we did our best to grab it. Now if you find yourself in a magic moment, your baby is sitting happily on the rug playing with her toys and beautiful soft light is coming in from the window, quietly get the camera and shoot, a lot! Don't direct her play or try to break her concentration. The moment will be lost as quickly as it started. You might try to interact gently by saying something that may get her to look up at you but overall, let her be her and seize that moment to shoot forty, sixty or more images. Don't overthink it; just shoot. In that group, you will likely have one or two that amaze you.

Here's an example. I placed this sweet sleeping baby on her parents' bed and opened up the window and the door and photographed away. Notice how I zoomed in and out to include more of less of the background. I tried vertical and horizontal compositions and even got up on the bed and stood over her for an overhead view. I moved her hands a little and adjusted the blanket. Once I picked out my favorites, I tried a few in black and white.

The set up: a sleepy baby and a bed by the window. Simple and pretty! These images were taken in the morning using ISO 500 and a 50mm lens.

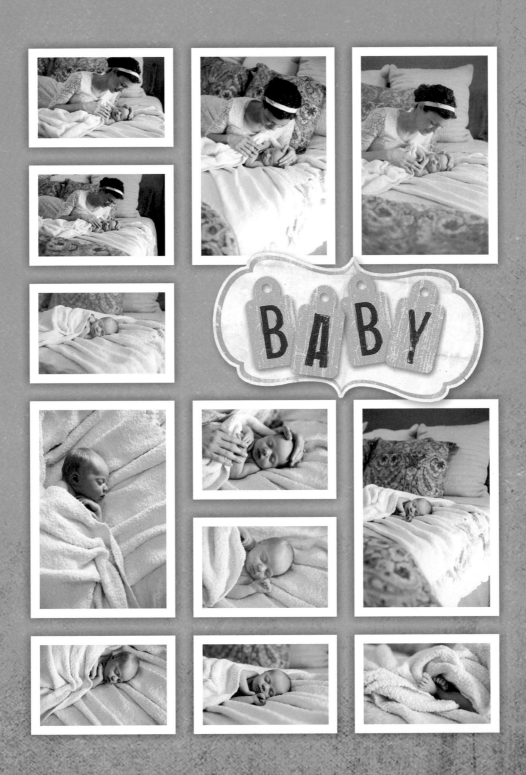

CHAPTER 5
Backgrounds & Foregrounds

When I say "your frame" I don't mean the frames on your wall. The frame that I am referring to is the viewfinder in your camera. When you look through the lens, or at the screen, that's your frame. When most people take a picture, they only look at the subject and worry about where it is in the frame. I also want you to begin to look behind your subject and around your subject. I want you to notice the background elements as well as what might be in front of your subject.

Another simple way to improve your photographs is to clean up the background. Busy backgrounds can ruin an otherwise amazing image by taking the focus away from the subject. So how can we remove the street signs, trees, toys, unfolded laundry piles, lamps and so on from our images?

This common problem can be solved in a couple of ways. The first is simple, and we discussed it when we talked about getting in closer. Getting closer may crop

the distracting items out altogether and, if you zoom in with your lens, blur your background a little. If getting closer is not possible, try taking a step to the side or ask your subject to step to the side, which will change the way the background lines up with your subject. If all else fails, see if you can move the action to a new location.

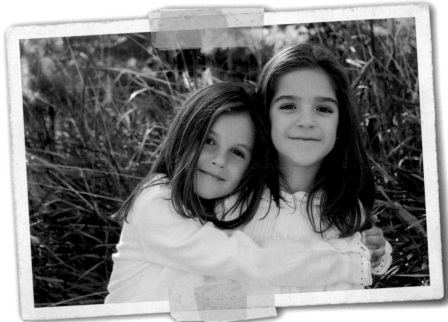

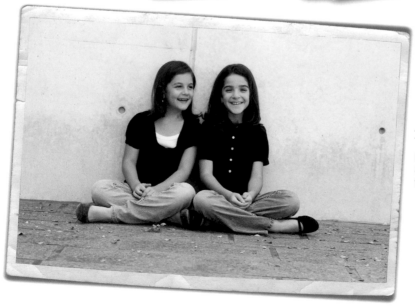

The same sisters photographed two years apart. It's amazing to see the changes.

As you work to clean up the backgrounds of your images, don't forget to pay a little attention to your foreground as well. Adding something into the foreground of your image can bring new depth and detail into your photograph. Move from side to side and see if you can add a little foliage to the foreground of an outdoor shot or maybe an architectural element. Be playful and include something whimsical.

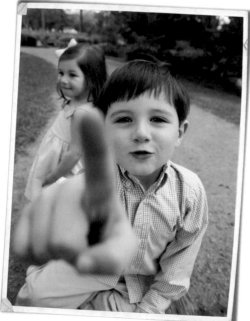

GIVE THEM SOME SPACE

I know, I know. Earlier I told you to get closer. Every so often, though, you do need to back up and give your subject a little bit of space. In certain scenarios, including a bigger picture of the scene really adds to the story that you're telling. If the location is part of your story, back up (or zoom out) and include it.

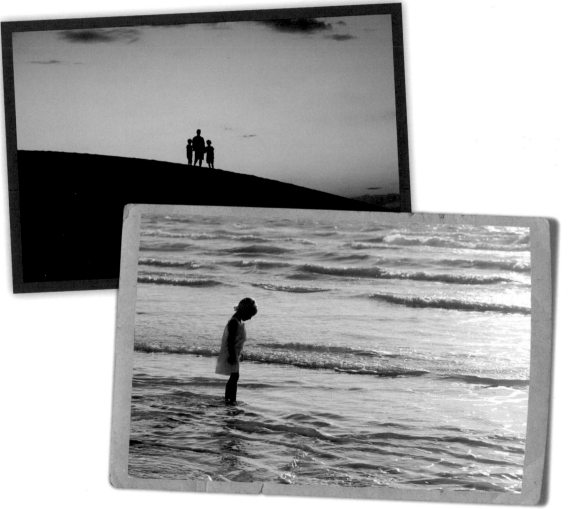

THE ART OF
THE SMARTPHONE

YOUR BIG, FANCY DSLR isn't going to do you much good if it stays at home in your camera bag all the time. Truth is, for many of us, the camera we always have with us is our phone. Photography is what I do every day, and I find myself with only my phone quite often. The great news is that you can do amazing things with your phone camera these days. If you have one of the more sophisticated smartphones then you probably have a pretty decent point-and-shoot with you all the time. It certainly won't replace your DSLR in quality and control but it can serve as a great learning tool and go-to camera.

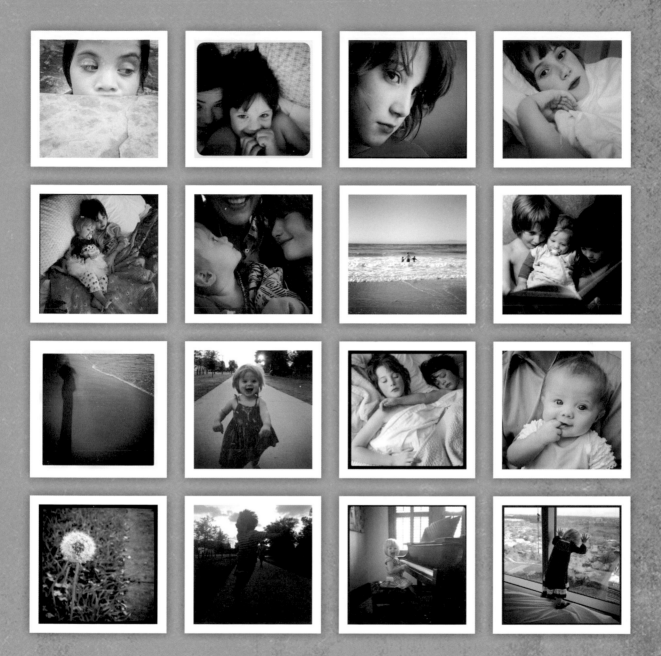

The best way to become better at photography is to shoot more. Every picture that you take makes you that much better. Every click helps you learn to see things in a new way. Smartphone Apps like Instagram, Smug Mug's Camera Awesome, PicTapGo and VSCO cam (just to name a few) make cell phone shooting really creative and fun. The trick is to use these apps to experiment, play, try new things and shoot things you might not normally photograph. Think about your phone as a photographic sketchbook and challenge yourself to find the beauty and whimsy in the everyday moments.

CHAPTER 6
ExposureBasics 6

"YOU DON'T TAKE A PHOTOGRAPH, YOU MAKE IT." – Ansel Adams

know that your camera scares you. Cameras used to be simple and a lot less intimidating. The camera that I learned on had three basic controls and maybe one or two other options to toy with. I even had to wind it! As technologies grow and improve, the camera manufacturers just keep adding more and more bells and whistles to their products. While it's great to have so many amazing tools at our fingertips, all the options, buttons and icons oftentimes just end up creating a scary interface.

And the manual? The manual is full of technical terms that most people aren't familiar with, and on top of that, the explanations are difficult to understand. If you have no idea what the different controls are called or what they do, how can you know what to look for in the manual?

I'm going to boil the inner workings of your camera down to the very basics. Despite their appearance, cameras are still pretty simple. In order to take a well-balanced picture, your camera has to come up with an exposure. When you point your camera at a subject, focus and click, your camera decides how much light is available and how much light is needed to make the picture come out correctly. That's what we call exposure. Your camera does this with an internal light meter. An exposure is made up of three basic factors: the ISO setting, the aperture (or f-stop) and the shutter speed. Let's start by breaking these down one by one.

GO SLOW This section can be tricky and a little confusing. Try to grab on to the concepts more than the details. As you read and practice, it will all become clear. Taking the time to understand how your camera actually works and thinks will pay off a hundred-fold later on.

THE LIGHT METER

The light meter is the brain in your camera. It's a simple brain, too. It has no idea what you are photographing. It sees a rock, a person, a lake and a house exactly the same way. It simply measures the amount of light that is being reflected off your subject and back at the camera's lens. Then based on the lighting conditions, it creates a combination of ISO, f-stop and shutter speed that it thinks will work for you. I'll go over ISO, f-stop and shutter speed one by one, so don't worry about what those are just yet.

Newer digital cameras give you a few choices for exactly how you want your camera's brain (the meter) to see the light. The default setting on most cameras is called evaluative, zone or matrix metering. The names of these metering modes differ from brand to brand but they all mean the same thing. "Default" means that you don't have to choose this setting because it's how your camera is already set up. With this default metering mode selected, the meter takes readings from various points (usually corresponding to the auto focus points that you see when you look through your viewfinder). It then takes the data from these points

and averages them all together to equal 18% gray, which looks like the picture on the right. I'm showing you this because I want you to see what your camera is seeing. It's important to know that it isn't seeing the world as you do. If you point your camera at white snow, it creates a reading to make that white this 18% gray color. If you point your camera at a piece of black fabric, it will create a reading that would render that black this 18% gray color. Why this usually works well and gives you accurate readings is that you have bright areas and very dark areas in most of your scenes and so the metering and then averaging to 18% gray process is the camera's best way to guess at how much light you need.

Building on what we just discussed, the default mode works well when you have an even number of darks and lights in a scene. There are other metering modes such as partial, spot or center-weighted, which allow you even greater control over how your camera's brain "sees" the light.

The camera's meter can be seen on the main info screen on the back of the camera, the smaller screen on top of the camera or the bottom of the screen as you look through the viewfinder. The location will depend on your camera model. You may see it in all of these places or just one.

If your camera is set on the fully automatic setting (usually a green box icon or similar), your light meter may not illuminate because the camera is figuring everything out for you. To find and activate your light meter, try setting your dial to **M** (manual mode) and then point your camera towards a light source (like a window) and then away. Make sure your lens cap is off. If you are in full auto, you may not see your light meter or it will not be active. What you are looking for is a scale that has a +1 and a +2 on one side and a -1 and a -2 on the other. You should see the bars or indicators move from the + to the - side as you do this. You may have to "wake up" your camera and the display by lightly pressing on the shutter release button (the button you use to take the picture). You may also need to move the selector dial to see the changes.

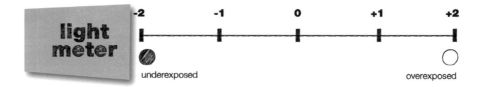

When you are using the semi-automatic modes or the manual mode, your light meter helps you determine which settings to use and whether or not you have enough light. If your picture is too light, the bar will move towards the plus side, or if it's too dark, it will move towards the minus side.

At this point, all you need to grasp is the basic concept of metering. You need to know that there is a light meter and that it measures light for you. You need to know where your light meter is displayed so you can refer to it later. The important thing to remember is that in order to take a picture, you need light. Most of the time, you actually need far more light than you might think. Your eye is better than your camera at gathering up light. What you see and what the camera sees are not always the same thing. For more on light metering, visit *www.farrahbraniff.com* and check out the video library.

ISO

Do you remember the days when you used to buy a roll of film? When you bought film, each box had a number on it and it was something like this: 100, 200, 400, 800, 1600 or 3200. You might have even known back then why you bought the 400 over the 100. Or maybe, like many folks, you never really knew what that number meant. In the most simplest of terms, the ISO number is an indicator that tells your camera how much light is available at the time that you are taking the picture. It does this by controlling how sensitive the camera is to light.

When you shoot on the fully automatic mode, your camera decides on an ISO and sets it for you. This auto setting of the ISO will work pretty well on many occasions. But when it comes time to take control of your ISO, you need to know where it is and what it controls.

ISO numbers set a level of light sensitivity. Common ISO choices will be 100, 200, 400, 800, 1600, 3200 and 6400. The lower numbers, like 100, tell your camera that there is abundant light available for creating the image (think bright, sunny day) and to be less sensitive to that light. This allows the sensor to take pictures when the scene is bright without the picture coming out too bright, which is referred to as overexposed. The high numbers, like 3200, tell your camera that there is limited or low light available for creating the image (think home interior, auditorium) and to be more sensitive to that limited light. This allows you to take a picture in lower light conditions and not have it be too dark, which is referred to underexposed.

For most camera models, 100 will be the lowest ISO option and 1600, 3200 or 6400 will be the highest. Right in the middle of the ISO continuum, you have numbers like 200, 400 and 800. These would be average, or middle-of-the-road, settings. As you experiment with changing your ISO, you will begin to learn which numbers work best in different scenarios. For now I just want you to absorb this concept: ISO is about telling your camera how much light is available and how sensitive you want the digital sensor to be to that light. Knowing how to manually set your ISO will allow you greater control over your camera. It will also help you take better indoor photographs (more on indoor photographs later).

WHEN SHOULD I MANUALLY ADJUST MY ISO?

Perfect question. Have you ever been in a low light situation and the pictures came out reddish orange, yellowish and blurry or the camera kept beeping at you and just wouldn't take a picture at all? Or, the flash auto popped up even if you didn't want to use it? Conversely, you might be trying to take a picture outdoors and it looks too bright or washed out. All of these are signs that you have too little or too much light to create the picture that you want and your camera is struggling to find a good setting for you.

Learning how your camera works, thinks and sees is the foundation of better photographs. Knowing how to override the auto setting and manually adjust your ISO to better fit the amount of light that is available is a hugely powerful tool.

The main thing to understand now is that **the ISO controls how sensitive your camera is to light.** You can manually control this setting when you need to or leave it on auto (or a bit of both).

iso

| 100 | 200 | 400 | 800 | 1600 | 3200 | 6400 |

lowest light sensitivity highest light sensitivity

Here are some general guidelines. Keep in mind all lighting conditions differ, so use this only as a jumping off point. The lowest speeds (100-200) would be used in very bright light conditions, like mid-day on a sunny day. The middle range (400-800) would be good on an overcast day, in the afternoon or in a brightly lit interior. The highest speeds (1600 and up) are for darker interiors, or when the sun is going down.

F-STOP / APERTURE

Now that you understand that your camera sees the light using the light meter and know how to set the camera's light sensitivity using the ISO, we'll go over how the light goes from the outside world into the camera to actually create the image. Inside your camera's lens is an opening in the shape of a ring. This ring can be opened wider or shut smaller by setting the camera's f-stop (also called an aperture) setting.

When the aperture ring in the lens is wide open, it lets in the maximum amount of light possible. When you close down the aperture ring and make the opening smaller, less light is able to pass through into your camera. When you think about your f-stop, think of it as controlling the *volume* of light that is allowed into your camera. If the f-stop ring is set to a small opening, it will let in only a small amount of light and vice versa.

The size of the opening corresponds to f-stop numbers on your camera. Some common f-stop numbers are:

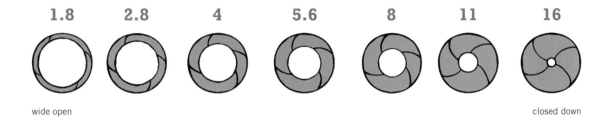

| 1.8 | 2.8 | 4 | 5.6 | 8 | 11 | 16 |

wide open closed down

ISO & CAMERA MODES If your camera is set to a fully automatic mode (the green box icon), you may not be able to manually change your ISO. To experiment with changing your ISO, you may need to switch to the **P** mode versus the ■ or the green box mode. **M** (manual) or one of the other semi-automatic modes will allow you to change the ISO as well.

There are also numbers in between these, which you can think of as half stops. Just to make your photo life more complicated, and this concept harder to remember, the small numbers correspond to the bigger opening in the lens and the higher numbers correspond to the smaller aperture openings.

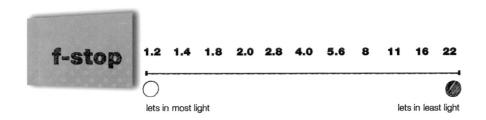

Don't worry about memorizing f-stop numbers just yet. **For now, all you need to remember is that your f-stop controls the volume of light let into your camera through the camera's lens.** You should also become familiar with where this number is displayed on your camera's menu screen. Your camera may display the f-stop number with an F preceding it, or may not. A little later on, we'll go into greater detail about f-stops and the amazing things that they can do for your pictures.

SHUTTER SPEED

The third piece of the exposure puzzle is shutter speed. Your f-stop is inside your lens, but the shutter is inside your camera's body. It's a little door mechanism that, literally, opens and shuts. It opens to allow the light that is coming in through the f-stop opening in your lens to pass through to the camera's digital sensor and record the image. While the f-stop is controlling the volume of light coming in, the shutter speed is controlling how long that volume of light is allowed to touch the sensor. The shutter speed is how fast the shutter door opens and closes. Your shutter speed will be displayed on your menu screen or LCD near your f-stop number.

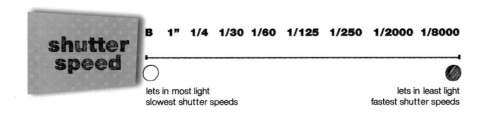

Shutter speeds can go from B all the way up to 8000. B allows you to hold the shutter open for as long as you hold down the button. The highest numbers like 8000 will be your fastest speeds. Shutter speeds are displayed differently on various camera models. Some will display them as fractions (1/60 for example) while

others will show a whole number (60). However your camera displays them, they are either whole seconds (displayed by adding an apostrophe after the number, like this: 6') or fractions of a second (1/6). So, if you see the number 125 (as an example) it is telling you that the shutter door is open for 1/125th of a second.

There's no need to go memorizing all your shutter speeds right now. Rather, I want you to find where the shutter speed on your camera is displayed and scroll through the speeds to see them. **At this moment, all that you need to internalize is the concept that the speed of the shutter controls how much light gets into the camera. More time = more light and less time = less light.** Later on, I'll be more specific about shutter speeds, why you would choose the different speeds and what their effect on your images will be.

CANON CONTROLS

Here is the back of a Canon T3i. Your camera may be a bit different, but the basic layout on other Canon models should be similar.

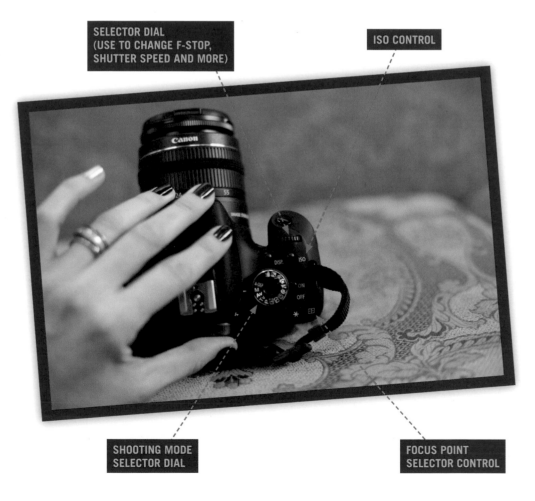

SELECTOR DIAL
(USE TO CHANGE F-STOP,
SHUTTER SPEED AND MORE)

ISO CONTROL

SHOOTING MODE
SELECTOR DIAL

FOCUS POINT
SELECTOR CONTROL

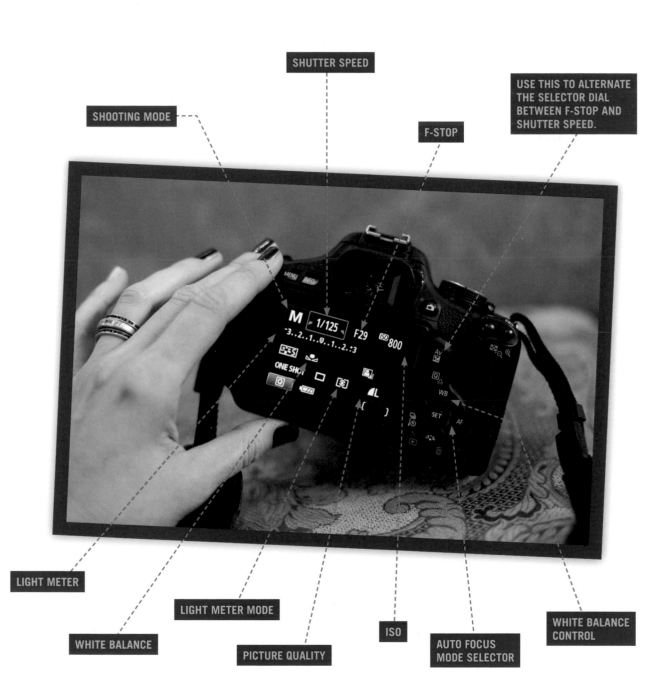

SHUTTER SPEED

SHOOTING MODE

USE THIS TO ALTERNATE THE SELECTOR DIAL BETWEEN F-STOP AND SHUTTER SPEED.

F-STOP

LIGHT METER

LIGHT METER MODE

WHITE BALANCE

PICTURE QUALITY

ISO

AUTO FOCUS MODE SELECTOR

WHITE BALANCE CONTROL

You can go to my web site, *www.farrahbraniff.com* for more in-depth videos detailing popular camera models and for a walk through on these basic controls and menus.

NIKON CONTROLS

Here is the back of a Nikon D90. While your Nikon model may differ slightly, the basic layout should be similar and help you locate your controls.

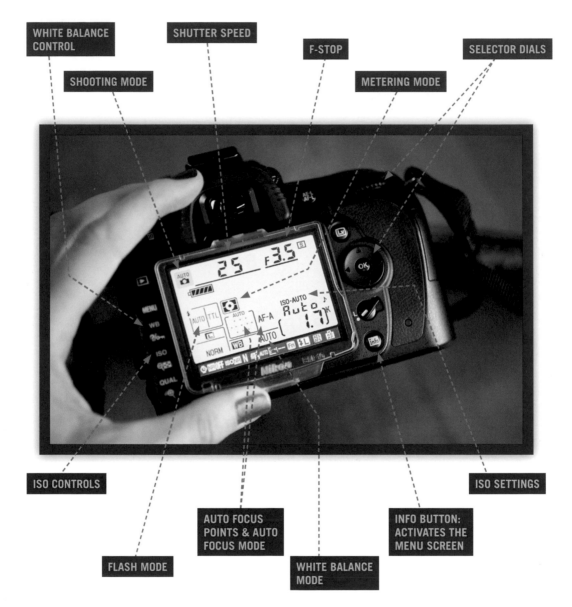

WHITE BALANCE CONTROL

SHOOTING MODE

SHUTTER SPEED

F-STOP

METERING MODE

SELECTOR DIALS

ISO CONTROLS

FLASH MODE

AUTO FOCUS POINTS & AUTO FOCUS MODE

WHITE BALANCE MODE

INFO BUTTON: ACTIVATES THE MENU SCREEN

ISO SETTINGS

You can go to my web site, *www.farrahbraniff.com* for more in-depth videos detailing popular camera models and for a walk through on these basic controls and menus.

EXPOSURE WRAP-UP

- **Exposure is created by a combination of your ISO, your f-stop and your shutter speed.**
 Each of the three exposure pieces affects the others. Each of them controls light. They bring light into your camera in three different ways, and each has a different effect.

- **Your camera measures how much light is available by using the built-in light meter.**

- **Your camera doesn't see people, landscapes or monuments, it sees light reflected off of your subject.**
 Your camera is a machine. It does its best, but the more you know, the better your shots will be. You can make decisions based on your own feelings, the subject and what story you are trying to tell. When you know how your camera works, your pictures will improve.

- **Your ISO controls how sensitive your camera is to light.**

 Your f-stop controls how much light is let in through your lens.

 Your shutter speed controls how long the light let in through the f-stop will touch the digital sensor.
 This is all you need to know right now. We'll go over each piece in detail and the reasons why you would adjust one over the other will become much more clear.

- **Go to *www.farrahbraniff.com* and watch my video tutorials on exposure.**
 Watching me teach the technical topics will make exposure easy to understand.

METERING MODES

EARLIER, WE TALKED ABOUT LIGHT METERS. The way that your camera knows how to calculate an exposure is through the light meter. On most cameras there are various light metering modes that help you get specific about how you want the camera to "see" the light and make its calculations.

The default metering mode on Canon cameras is called evaluative. Nikon's default mode is called matrix metering. Every camera is different, so yours may have another name. The default mode takes light meter readings from various evenly distributed points throughout the image (usually the same ones as your auto focus points) and averages them together to create the exposure. This mode works for most images, which is why it is set as your default. Your camera will also have some partial metering modes, like center-weighted, partial and spot mode. These selective modes gather data from a specific point (that you select) or from a specific area (like the center) of the image.

In most cases, your camera will work perfectly on its default setting. There are some situations that would be better served using the other modes, like when you have a scene that is backlit. When you have back lighting, the default metering mode will try to find an exposure that makes both the bright background and your darker subject look good. The problem is, when the light in the background and foreground are really different, making them both look good is usually not possible.

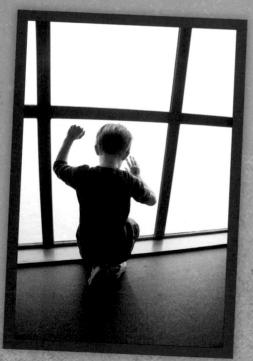

Let's look at an example. This first shot was taken using the default metering mode. The problem here is that we have no idea what he's looking at and so our story is lost.

In this type of backlit situation, unless you add light with a flash, you have to make a choice of which part of the image you want exposed well and let the other go dark or light. You'll either have the background looking good and he'll be completely black, or you'll get what we have here. He is exposed well, but we've lost the background entirely.

Image 1

The solution to this problem is to pick the spot metering or the center-weighted mode and meter more selectively. You need the meter to only read the area that you want to be exposed properly. In this case, I want the view to be exposed properly, and I'm okay with my son going a little darker. So, I switched over to the spot metering mode and aimed my spot at the ocean background. Once I had the exposure looking the way I wanted (image 2), I took some time to adjust my composition and ended up with an image that told my story so much better (image 3).

You will need to refer to your camera manual to find the button or menu option on your camera that allows you to change the metering mode. In your manual's index, look for "metering modes." Also, refer to the camera diagrams on pages 57-58 for help locating the metering mode indicator on your menu screen.

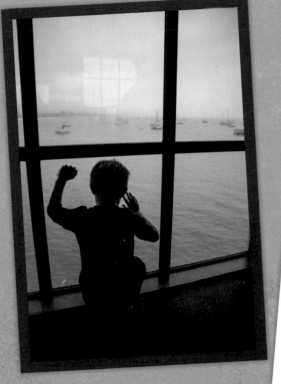

Image 2

I didn't like the window reflection or the crooked horizon line in this image so I took a little time to try an alternative composition in image 3.

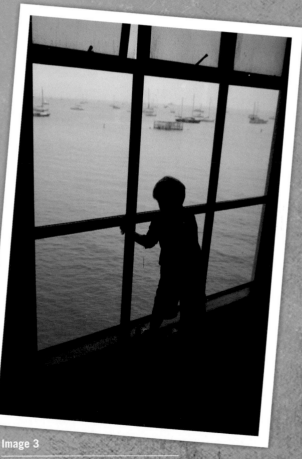

Image 3

My final image, just as I envisioned it.

Here is another example. This shot was taken inside on a bright day. Cameras don't have an infinite latitude when it comes to creating an image. If the gap between the dark areas (inside, in this case) and the bright areas (outside) is very wide, the camera tries to find a middle ground. In the first shot, I used the default metering mode and the camera is trying its best to render both the brights and the darks in as much detail as possible. If I switch the metering mode to spot and put the center focus point on the window, I get the image in the second picture. Lastly, I used the spot meter and metered the walls inside (placing the spot in between the windows on the wall).

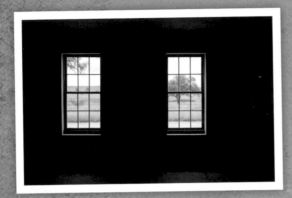

Metered in the default metering mode. The outside is a bit light and the inside is a bit dark. This is the camera trying to create compromise.

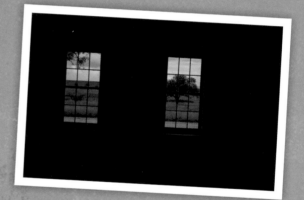

Metered in the spot metering mode with the spot trained on the outside (the windows). Notice how dark it gets inside when the exposure is correct for the outside.

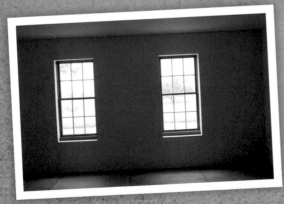

Metered in the spot metering mode with the spot trained on the walls inside. Here the inside of the room looks good but we've lost the exterior.

So, which one is "right?" That's for you to decide! Which one tells your story best and fits the shot that you intended to take?

HOW TO PRACTICE

- Look in your camera manual to locate the controls for your alternative metering modes. Take a moment to figure out what modes your camera has available and read the descriptions given for each one.

- Look for a scene like the one with the windows. Try using the spot metering mode as well as your other modes to imitate the window images to the left. Maybe your very own living room has a scene like this? Other ideas for this type of exercise would be a situation where your subject is backlit by bright lighting. Arrange your subject where the sun is at his back and try this experiment.

- Once you feel confident with the metering modes (especially spot) look for a backlit scene like the example with my son and try to emulate those shots.

- On most camera models, the spot meter uses the autofocus points that you see when you look through your viewfinder. In the default mode, it uses them all. In the spot mode, it uses the center one. Most cameras will allow you to move that spot simply by moving the autofocus point. Check your camera manual's index for "spot metering" and for "auto focus point." I also have a video on my website *www.farrahbraniff.com* that shows you how to control your auto focus point.

CHAPTER 7
Capturing Motion 7

"A PHOTOGRAPH IS THE PAUSE BUTTON ON LIFE." – Ty Holland

When you see an amazing sports image, with the athlete perfectly frozen in mid-air, you are seeing shutter speed in action. By controlling the speed of your camera's shutter, you can freeze or blur motion. This is especially important if the story you are trying to tell depends on seeing the motion. If you are photographing your kids playing sports, doing cannonballs into the pool on a summer day or swinging on a swing set, you need to freeze the motion. Knowing how to control the motion in your images is a powerful creative tool that can radically improve your photographs.

When I introduced exposure in chapter 6, I explained that ISO, f-stop and shutter speed are the cornerstones of exposure. Now, we're going to go more in-depth about the shutter speed. The best way to understand shutter speed is to picture the shutter as a little door that opens up and records information while it's open. In order to freeze your motion, you need to match up a shutter speed with the speed of your subject. If the shutter door opens and closes faster than your subject is moving, you will freeze the action completely. If the shutter opening and closing is slower than your action, you will get motion blur.

The high shutter speed numbers are the fastest. Always remember to think of them as fractions of seconds. When you think of them this way, it's easy because 1000 or 1/1000th of a second is clearly faster than 60 or 1/60th of a second.

When you are shooting indoors and your images are coming out yellow-ish and blurry, it is most likely because your shutter speed is too slow. When your camera is set on automatic, the shutter speed will slow down in lower light conditions. It is slowing down and staying open longer in order to get as much light into your lens as possible, but it stays open too long and causes blur.

Step one is to locate where the shutter speed is displayed on your particular camera. You can refer back to the camera diagrams on pages 56-58 or check your camera's manual to find its location. Set your camera on **TV** (time value) or **S** (shutter speed priority mode) or **M** (manual). This will allow you to change the shutter

speed. This is usually done by moving the selector dials (your camera should have one or more of these). Move the selector dial to see the shutter speed changing and make note of the numbers.

Next, let's talk about how you know which shutter speed to choose. Here are some basic guidelines. These are not absolutes, but they will help get you started.

- **Below 30 (1/30):** Use these speeds when you want to create motion blur.
- **60 (1/60):** Still objects or adults. Anything below 60 will risk slight to severe blur unless you are using a tripod and your object is completely stationary.
- **125-250 (1/125 to 1/250):** Pets and young children being fairly still, sitting, talking or engaging in calm play.
- **500-up (1/500 and up):** Vigorous play, sports and faster motion.

In this series, my son is shaking his head from side to side.

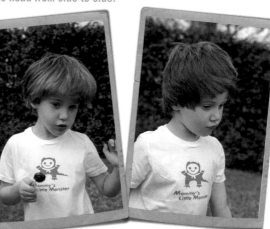

1/30ᵗʰ of a second 1/60ᵗʰ of a second 1/500ᵗʰ of a second 1/2000ᵗʰ of a second

Jumping

1/30ᵗʰ of a second

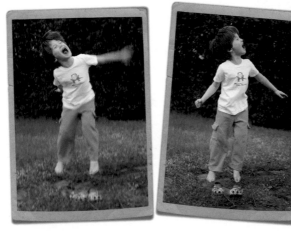

Jumping

1/5000ᵗʰ of a second

MOTION TIPS

If you are shooting with a point-and-shoot and don't have the shutter speed priority shooting modes (**TV** or **S**) on your dial but you do have the graphic symbols like the mountain, the flower or the running man, you can use the running man icon to help freeze your motion. When you select the running man icon on your dial, your camera will do its best to use as high a shutter speed as the available light will allow. Just choosing the running man icon will not guarantee that your motion is frozen, but it is helpful in the right lighting scenario (usually outdoors). If there isn't enough light (for instance, if you are shooting indoors), the shutter speed may not be able to go fast enough to freeze the motion.

The hard part is matching a shutter speed to the speed of your action. How fast your shutter speed needs to be to freeze motion will depend the speed of the action, and all motion is different. For example, if you are photographing a person sitting across the table from you, and they are very still, you can use a slower shutter speed. If this person is animated and gesturing with his arms, you would need to choose a faster shutter speed. This is something that just takes practice and experimentation, so be patient with yourself as you play and learn.

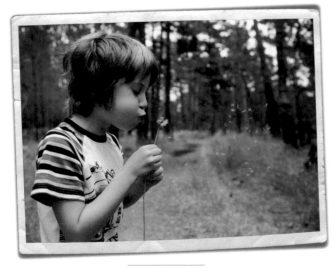

Moderate action

Fast action

The best way to start experimenting with shutter speed control is to use the shutter speed priority mode on your camera. For Canon users, look for **TV** on your dial. If you shoot Nikon, it will be the S mode. Most cameras use either **TV** or **S**: check your camera's dial or refer to your manual. In the shutter speed priority mode, you choose a shutter speed and the camera will match it up with an appropriate f-stop.

All of these images are about motion. Freezing that motion helps tell the complete story.

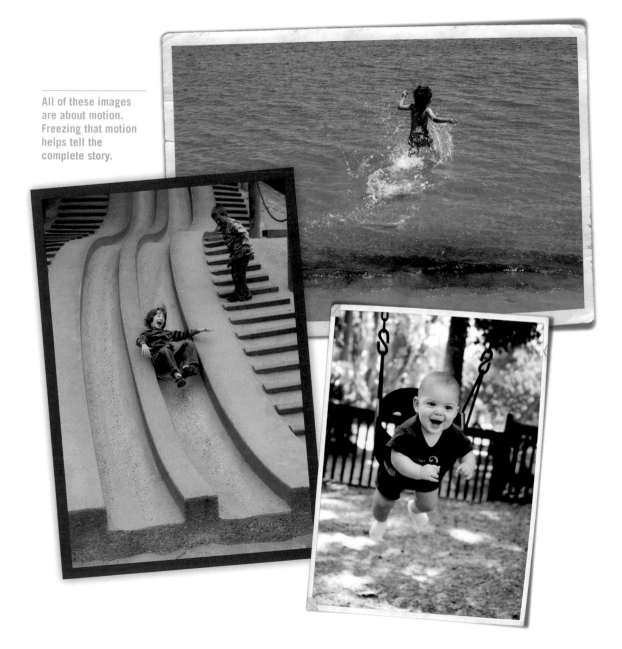

When you check the images on the back of your camera to see if your motion is truly frozen, make sure and zoom in on the image. Pretty much everything looks awesome shown a few inches by a few inches on the back screen of your camera. When you zoom in, though, you might notice that it's just a little bit out of focus and that raising the shutter speed a click or two to a faster speed will make your image much sharper.

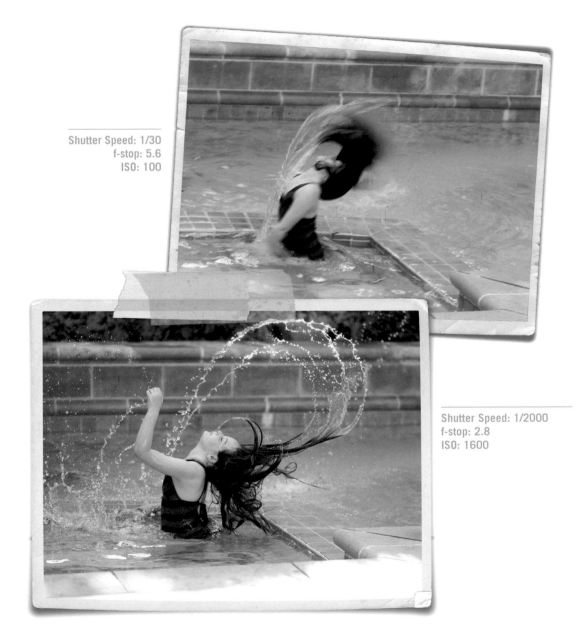

Shutter Speed: 1/30
f-stop: 5.6
ISO: 100

Shutter Speed: 1/2000
f-stop: 2.8
ISO: 1600

You might also find that when you photograph kids, dogs or adults who move quickly or gesture a lot while they talk you need to raise up your shutter speed or risk partial motion blur or focus that is not sharp. You might find that one of your images is "soft." It's not out of focus completely, but it's not tack sharp either. This can be fixed by adjusting your shutter speed to a higher (faster) setting.

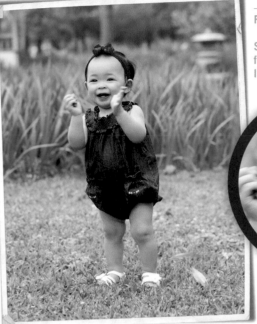

Face is in focus, but her hands are blurry.

Shutter Speed: 1/200
f-stop: 4.5
ISO: 160

**Same as above: while her face
is sharp, her hands are not.**

Shutter Speed: 1/60
f-stop: 4.0
ISO: 800

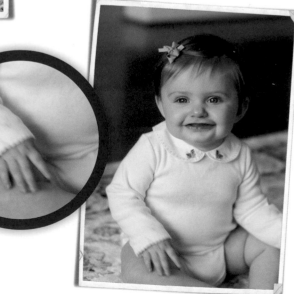

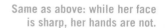

Once you feel confident freezing your motion, why not try blurring it on purpose? Purposeful motion blur can be wonderful as well! To really have fun experimenting with purposeful blurring of motion, you will want to invest in a simple tripod. If you can keep your camera still, you can keep the still items in your picture clear and sharp while letting the moving parts go blurry.

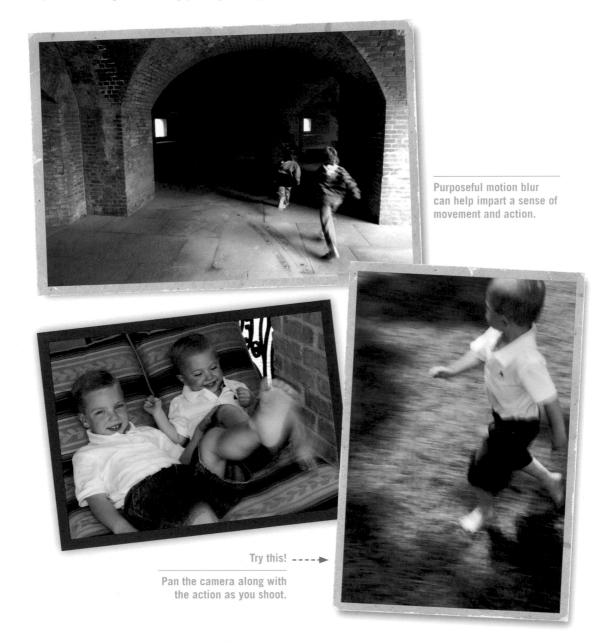

Purposeful motion blur can help impart a sense of movement and action.

Try this! ----→

Pan the camera along with the action as you shoot.

HOW TO PRACTICE

- Find something that is moving. Enlist a friend to jump around for you or swing her hair. Turn on the water hose and prop it up so you can photograph the water coming out. You want the motion to be as continuous and steady as possible. If the speed of the motion that you are photographing is always changing, it will be harder for you to gauge the shutter speed/ motion correlation.

- Shoot this outdoors in a bright shady spot. This will not work indoors.

- Put your camera on the **TV** (Canon) or **S** (Nikon) mode. Start with a shutter speed of 8 (1/8). Take a picture. You should see a blurry image. Click up from there increasing your shutter speed and take another, and repeat. As you go higher, you should see the motion begin to freeze. Keep going until you are above 1000 (1/1000) or higher.

- If your images become too dark as you go up in shutter speed, try adjusting your ISO to a higher number. If they become too bright, adjust your ISO to a lower number. By adjusting the shutter speed, you are letting more or less light in through the shutter door and therefore need to adjust the ISO/ light sensitivity.

- Try this experiment with a few different types of motion. Let your kids do cannonballs in the pool or do silly jumps or dances for you.

TIPS ON POSING

IF YOU EVER WATCH CELEBRITIES WALK THE RED CARPET, you will notice that when they stop for photographs, they don't just stand there, they pose. Even the slightest body curve or turn can make an image more flattering. We're talking about kids, though, and kids don't pose. Kids are all over the place. Just getting them to stop for a second may be a miracle, much less posing them once they are there. While perfectly posed kids may be impossible (and, honestly, who would want that, anyway?) there are a few things that you can keep in mind to make your images just a little bit better.

INTERACT WITH THE SCENE
Try using something in the scene as a posing aid. Is there a chair to lean on? A railing? A wall? Instead of standing in front of the scenery, how about getting them to interact with it?

TWIST AND TURN

Instead of having your subject stand static and straight across from you, try adding a little twist or turn. This is not something you would do with a two year old but your tweens and teens can take a little direction. Just a slight tilt or three-quarter turn can make an image feel more dynamic and make your subject look more relaxed.

LEAN IN, SNUGGLE UP AND GET CLOSE

Just as getting closer to your subject makes a huge difference, getting your subjects closer to each other works magic as well. When people have distance between them in the photograph it feels more formal and less intimate. If you're photographing kids, friends and families, you want intimacy. You may have to encourage your subjects to get in close and they may feel like they are on top of each other, but the end result will be worth it.

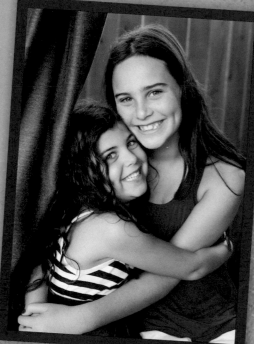

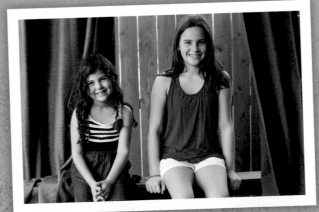

CHAPTER 8
Depth *of* Field

"WHICH OF MY PHOTOGRAPHS IS MY FAVORITE? THE ONE I'M GOING TO TAKE TOMORROW." – Imogen Cunningham

Depth of field is the technical gem that will take a pretty good image and make it great. Depth of field controls how focused your image is behind and in front of your subject (the background and foreground areas). When you take a picture, you focus on your subject using your camera's auto focus, and your choice of f-stop will affect the background and foreground focus.

Usually in a portrait, you want the viewer to focus on the person's face. A busy background can compete with that. Here's an example that shows how a blurry background isolates the subject's face and removes any distracting background elements.

When the background is soft, the subject stands out and doesn't compete with a busy background. As you can see in the example, when you are photographing people, softening up the background keeps the emphasis on the eyes and the facial expression and makes for a much more powerful portrait.

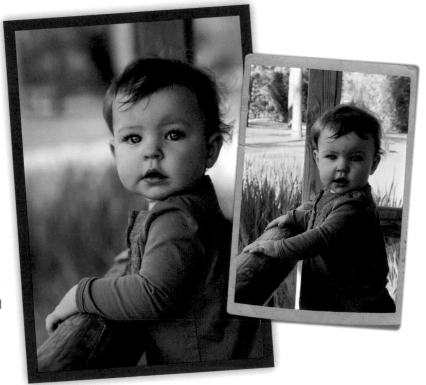

The f-stop numbers control the size of your aperture, which is the opening in the lens of your camera that light passes through as it makes its way to the digital sensor. The greater the size of the opening or hole, the more light comes in to the camera; and the smaller the opening the less light is allowed in. The aperture controls the volume of light that enters the camera. The f-stop number on your camera controls the size of the hole. Small numbers correspond to larger holes and larger numbers correspond to smaller holes. I know, I know…it's opposite, and that makes it more confusing. The numbers go in a series like this:

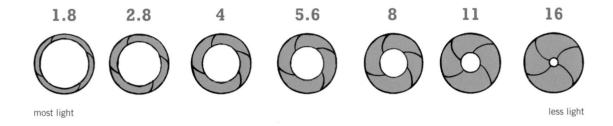

1.8 2.8 4 5.6 8 11 16

most light less light

These are just some of the numbers that you'll see when you find the f-stop settings on your camera. What you see exactly will depend on your lens, but these should give you a general idea what to look for. If you don't see some of the lowest numbers, it's because the lens you have does not open that wide. I'll tell you more about lenses later.

When you select a lower f-stop number (1.8, for example) more of your background and foreground will be blurry. If you select a higher number (22, for example) then you will have sharper focus in the background and foreground. One of the ways to remember this would be to think of it as a question: **how many things do I want to be in focus,** 1.8 or 22? While I can't guarantee that you will literally have one-point-eight or twenty-two items in focus, it will help you remember the difference.

When you are shooting something like a landscape you may want twenty-two items in focus, but when you are creating a portrait you will typically want a softer look in the background. When you master depth of field you can start to get very creative with it by isolating your focus to specific areas of your image.

For now, let's start with a basic way to start controlling your depth of field. If you are shooting with a DSLR, you should have a setting on your dial that says **AV** (Canon) or **A** (Nikon). Some of the point-and-shoots out there have this feature, too, so look around your manual or camera menu to find out if yours has this shooting mode. This mode is called aperture priority and is your new best friend. It allows you to choose an f-stop setting, and it will then choose the rest of your exposure for you. The "rest of the exposure" would be a corresponding shutter speed and an ISO (unless you have the ISO set on auto). It will choose the corresponding shutter speed and ISO based on the light that is available where you are shooting.

The aperture priority mode is a perfect way to experiment and learn how to control depth of field. It will take some time and experimentation, but the changes that you will see in your images will make the effort worthwhile. To help make this more clear, let's look at some examples. My son's toys have volunteered to act as models. Here are two images of Optimus Prime and his sidekick T-Rex. In one you see the background is in focus and in the other it is out of focus. The only difference between them is my exposure. I set the camera on my aperture priority mode, changed the f-stop settings and the camera changed my shutter speed for me.

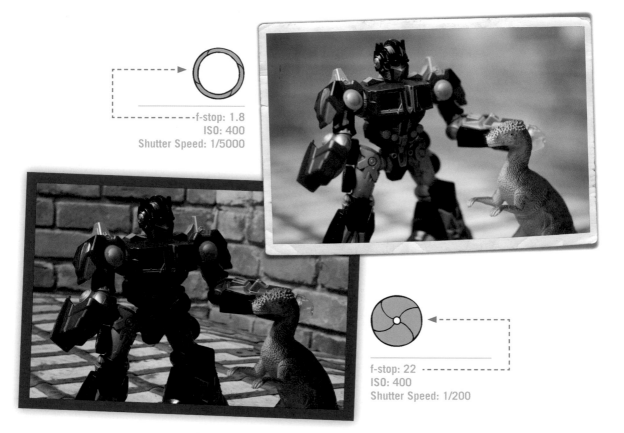

f-stop: 1.8
ISO: 400
Shutter Speed: 1/5000

f-stop: 22
ISO: 400
Shutter Speed: 1/200

F-STOP TIPS If your camera does not have the **A** or **AV** setting but only icons, this may be a little bit harder, but don't despair! The portrait mode (the face icon on some cameras) can do this pretty well. When you choose portrait mode, the camera will select a wide aperture setting for a soft background effect.

All pictures tell a story. The better the picture (meaning, the easier to "read" and understand), the better and more impactful the story can be. Let's get back to Optimus and T-Rex…If I wanted to tell a story about Optimus Prime having a battle with T-Rex and it was important that the viewer see where the battle was taking place, I would want my background to be in focus. If I want the viewer to focus on the action of the battle and not be distracted by the location, I could throw the background out of focus like this:

f-stop: 22
ISO: 1000
Shutter Speed: 1/125

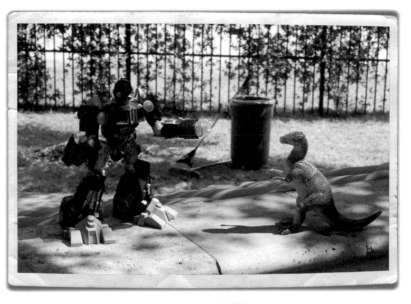

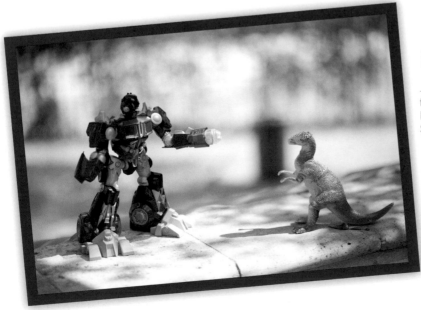

f-stop: 1.8
ISO: 1000
Shutter Speed: 1/8000

QUICK TIP!

- You don't want to use flash while experimenting with this project. It will change the look of things and make it more complicated. I would recommend turning your flash off before you begin.
- If your lens has f-stops like 1.2 and 1.4, you will need to be careful; at the widest f-stops, your depth of field can be so shallow that someone turned at a three-quarters angle to you may have one eye in focus and the other slightly out of focus. The best images have very sharp focus on the eyes.

If I wanted to take a portrait of this lovely couple and I wanted the viewer to really focus on the faces (and dare I say, the relationship between them?) and not on the distracting background elements behind them, then I would also want the background to be out of focus, like this:

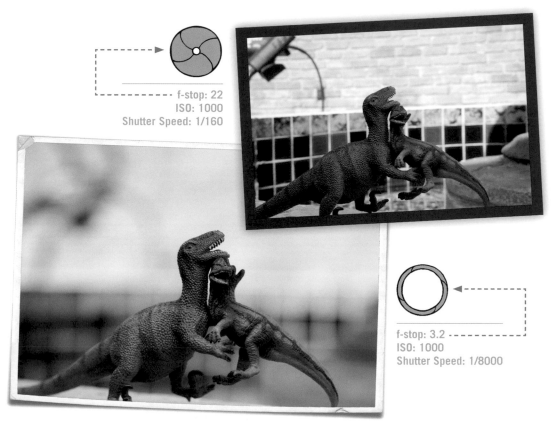

f-stop: 22
ISO: 1000
Shutter Speed: 1/160

f-stop: 3.2
ISO: 1000
Shutter Speed: 1/8000

If you really want to get a feel for the differences between the stops and practice this technique, I would set up a scene and take a picture at every f-stop (making notes so you can remember what you did). Here's an example of four different f-stops in one scene.

f-stop: 22
ISO: 1000
Shutter Speed: 1/160

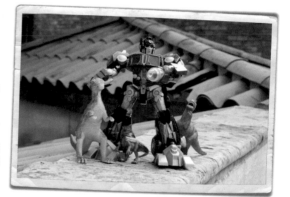

f-stop: 11
ISO: 400
Shutter Speed: 1/80

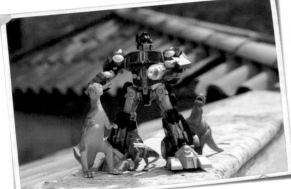

f-stop: 5.6
ISO: 1000
Shutter Speed: 1/2000

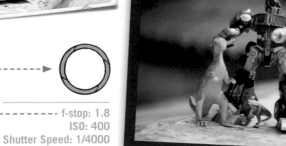

f-stop: 1.8
ISO: 400
Shutter Speed: 1/4000

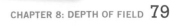

F-STOP QUICK TIPS

- Think about your own eyes. Your pupil is like the aperture ring of your eye. When the room is dark and your eyes need more light to see, your pupil dilates, allowing the maximum amount of light in. When you go outside, and it's bright, your pupil gets smaller.
- When you first experiment with this, use an object like a toy or a flower, not a toddler who won't sit still. You'll thank me for that, I promise.
- Depth of field is more dramatic when you are close to your subject and you are more "zoomed in" with your lens, so get right up close to your subject to test it out. To start off, zoom in to 50mm or more on your camera's lens. This is *crucial* in getting that soft background.

KEY CONCEPTS

- Aperture controls depth of field (think depth of focus if that helps).
- Big number f-stops = more things in focus. Little numbers = fewer things in focus.
- Aperture priority mode (AP) is a perfect way to begin trying this out.

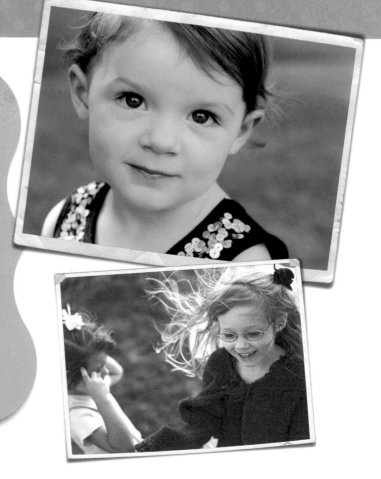

Once you've practiced with your Transformers enough, try moving on to an older child or an adult. Here's an example of the same scene photographed using low and high number apertures. I have included the technical data under the images in this chapter for those of you who are curious. If the technical data makes you confused, don't worry. It will become more clear as we go on.

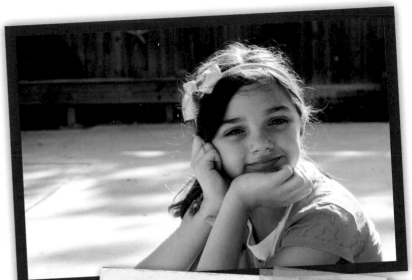

f-stop: 18
ISO: 1250
Shutter Speed: 1/125

f-stop: 3.2
ISO: 400
Shutter Speed: 1/640

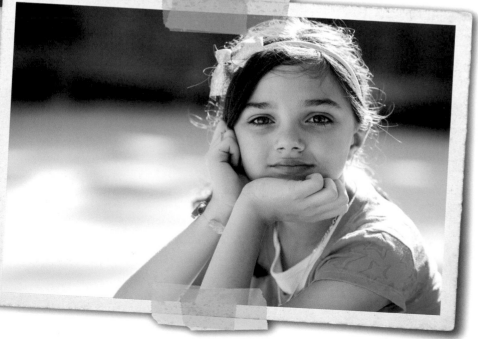

Use depth of field to isolate and emphasize the story. Soften and remove elements that are secondary and direct your viewer's eyes to your subject. Mastering this technical skill will help you create more meaningful compositions, stronger stories and more compelling images.

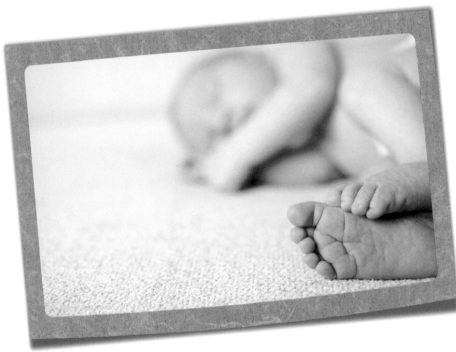

f-stop: 3.5
ISO: 125
Shutter Speed: 1/160

SHUTTER ALERT! When you do the practice exercise for depth of field and you are using the aperture priority mode, keep an eye on your shutter speed. The camera will raise and lower the shutter speed based on the f-stop that you have selected and the available light when you are photographing. If you allow the shutter speed to dip below 1/60th of a second, you risk motion blur. If, while practicing, you see your shutter speed falling below 1/60, try manually adjusting your ISO to a higher setting (higher number) to bring more light into your camera.

HOW TO PRACTICE

- Start with something still, like a toy or a flower in a vase. Take a series of shots and take notes on your settings.

- Use the **A** or **AV** mode on your camera.

- If you purchased your DSLR as a "kit" (meaning it came with a lens, usually an 18-55mm lens), you need to be sure and back up and zoom in as far as you can. Doing this will help make the effect more dramatic. Keep in mind that the kit lens may only give you 5.6 for your lowest f-stop number. This is not going make your background completely out of focus. It may only soften it.

- Make sure you are very close to your toys (try to fill the frame with them).

- Make sure the toys are not right up against your background or you won't see the effect. Keep yourself close to your subject and your subject far away from the background.

- Shoot on the same level as your toys, not down on them.

- Photograph outside so you have plenty of light. Find a bright, but shaded, location to set up your toys.

- Shoot an image at your lowest available f-stop number, then shoot the same image at various f-stops up from there. You should see your background change and become more in focus as your f-stop number increases, and vice versa.

USING COLOR AND SIMPLICITY

CONTROLLING WHAT IS AND ISN'T IN YOUR PHOTOGRAPHS will make them better. If your photos are cluttered and busy it is harder for the viewer to see the subject. Extraneous stuff draws your attention away from the subject and makes it less powerful. Next time you shoot, do your best to rid the scene of extras and allow your subject to be the main focus.

Simplifying your images can be done in a variety of ways. We discussed getting closer and cropping out unnecessary objects. You can also use your f-stop to blur something in the background that you want minimized. Sometimes, a simple shift to the right or the left can do the trick.

Color is another powerful tool that can help show off your subject. Bold and vibrant color can be incredible in your photos but sometimes simplifying your color palette is more desirable. Consider color when composing your images and let it help communicate and tell your story. Show off your child's bright blue eyes with a blue shirt or a blue background. If you love color and want a more vibrant and saturated look, add a punch of color with a prop or dress your subjects in vibrant clothing.

Can you use color to simplify or emphasize? The purposeful color palette in these images makes them have more impact. It emphasizes the faces and simplifies the story being told.

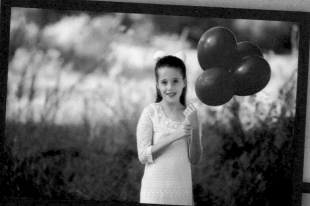

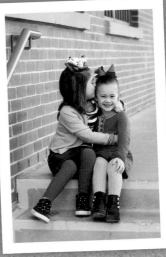

When you have more than one person, try coordinating clothing for a unified look. Paying attention to the overall color harmony of your images and being intentional with color will help your story and your children's faces shine through.

A willing tween or teen may really enjoy experimenting with clothing, locations and props. Play off of your model's interests for something truly creative. Let her be a part of the concept and it'll make her more willing and excited about the images.

CHAPTER 9
Shooting Outdoors 9

"LIGHT GLORIFIES EVERYTHING. IT TRANSFORMS AND ENNOBLES THE MOST COMMONPLACE AND ORDINARY SUBJECTS. THE OBJECT IS NOTHING; LIGHT IS EVERYTHING." – Leonard Misonne

Photography is, at its core, the study of light. Light is what makes a photograph dimensional. Light creates shape, details texture and illuminates the stories we are telling. When you take the time to look for light and harness it within your photographs, you will see an incredible transformation. Your images will come alive.

One of the most common complaints I hear from students is that their images are blurry and dull. One of the fastest ways to fix this problem and improve your photographs is to get out of the house and into the light. Not only is there not enough light at most indoor locations to create bright, color-rich images, but you also find bad lighting inside. Overhead, florescent or mixed light sources all have an impact on the color balance of the image and often push it towards the green, blue or yellow side. Some blessed individuals have huge windows and bright, sunny homes. If you do, you will have better luck with your indoor images. However, the vast majority of folks have poor lighting conditions in their homes and will have better results if the photo session is moved outside.

Now that we've gotten up and out of the house, what next? Let's talk about light: where to find it, what time of day is best and a few tips and suggestions on harnessing the bountiful and beautiful light that's waiting for us outside.

OPEN SHADE

One of my favorite times to photograph outdoors is when the sky is overcast but still bright. This is the perfect time to photograph children. It allows them to move around while the light remains relatively consistent. Because the sun is filtered by a layer of clouds, you get a bright, shadowless, soft light. Overcast days create something called open shade, which is simply shade that is bright and without dappled bits of sunshine or other pesky shadows. On an overcast day, you get this light everywhere. Open shade doesn't exist only on overcast days though. You may find a patch of open shade by the side of a house, under an eave, on the porch or anywhere else where the shade is open, bright and without dappled bits of sunshine.

Let's take a look at two images. The first is taken in bright, midday sunlight and the second is taken in open shade.

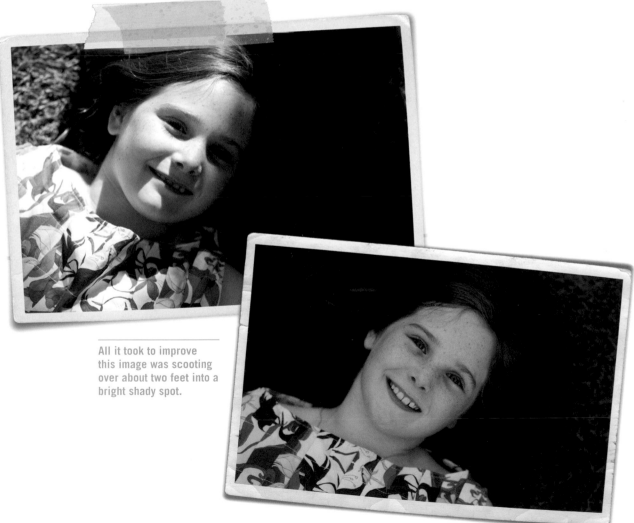

All it took to improve this image was scooting over about two feet into a bright shady spot.

Early morning light

WHEN IT COMES TO OUTDOOR LIGHT, TIMING IS EVERYTHING

There are good times and not so good times to photograph outdoors. Basically, you want the sun to be at an angle and not directly overhead. With this is mind, the best times to shoot outside are early in the morning (just after sun up) and in the later afternoon before sunset. This allows you to put the sun behind, to the side of or in front of your subject versus directly overhead.

Early morning is one of the most beautiful times of the day to photograph. The light is soft and diffuse. Once the sun is fully up and approaching midday, the light becomes harsher and difficult to work with.

Midday light is the worst. It's harsh and high in the sky. It hangs above, casting ugly shadows onto your subjects' faces. This is the time of day when you get dark shadows under chins and black holes for eyes. If you are photographing at this time of day, look for a shady spot to help soften the light.

Once the sun begins to descend in the sky, the light will improve. Afternoon light can be as pretty as early morning light. Late afternoon light is often called the golden hour. As the sun sets, the sky becomes rich with color. The light starts to fall away fast right before sunset but, if you can catch it, it's wonderful. As the sun sets, you will need to raise your ISO and open your f-stop to gather up more light.

Late afternoon light

GETTING LIGHT IN THE EYES

Clear, bright and sparkly eyes are beautiful, and your portraits will be instantly better if you know how to put some light into your subject's eyes. When you look at a photograph and see the light's reflection on the surface of the eye, it's called a catchlight. Without catchlights, eyes look dull and lifeless. The extra bonus of having nice, glittery catchlights in your subject's eyes is that, when you do, you will also have better light on their face overall, which makes the entire photograph better.

In this first image, the light is completely behind her. There is no light reflecting onto her face and it leaves her looking dark and shadowed.

In the second image, the light is in her eyes and on her cheeks and it transforms her face. You can actually see what color her eyes are! In the previous photo, her eyes look black and dark and in the second shot they are blue and bright.

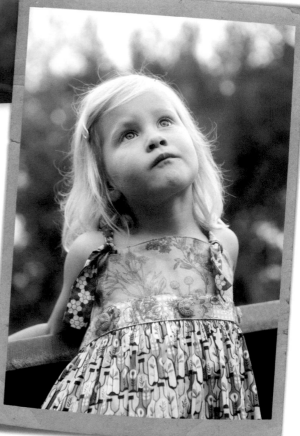

In this image, The light is coming from behind her and to her right. There isn't any light wrapping around or reflecting onto her face so her eyes look dark and are missing that sparkle we call a "catchlight."

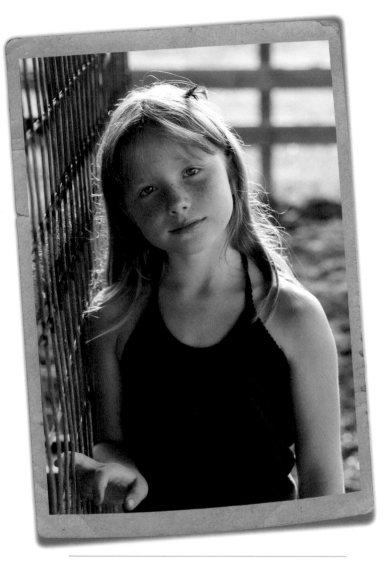

By changing my location to an area that had some cover overhead, I soften the light on her face, remove the harsh shadows that the direct sun was casting and her eyes become more illuminated. The sparkle in her eyes makes a huge difference!

In this image, the sun is only on one side and the light is too harsh. Half of her face falls into deep shadow and there isn't any light in her eyes.

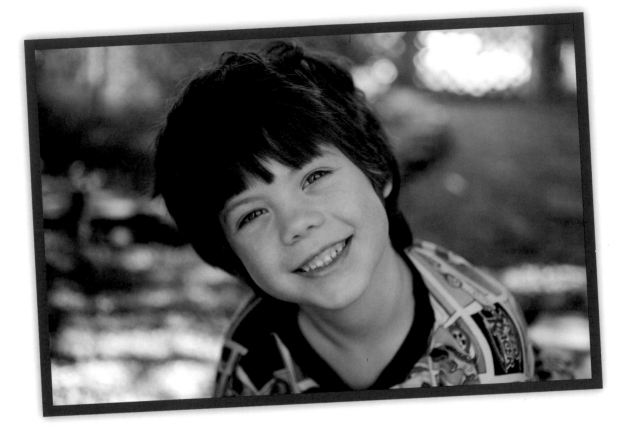

On a bright sunny day, you can combat the harshness of the sun by finding a shady spot. Looking at the background of this image you can see the bright spots on the grass and can tell that it was spotty and bright outside. By moving the action out of the dappled light and into a bright shady spot, I created a smooth and even light over his face.

LIGHT TIP See an image that you love and wonder how it was lit? Or where the light was coming from? You can usually tell from the reflection in the person's eye. Sometimes you can even see the reflection of the person taking the picture or make out the shape of the light source (like a window or a photographer's light). Studying the catchlights in a subject's eye can help you learn what types of light you like in photographs.

DIRECTION OF LIGHT

On a bright overcast day, your light will be coming from all around you with little discernable direction. On a sunny day, however, your light will be coming at you from very distinct angles. Learning how to see the light around you and learning how that lighting direction will affect your subject are huge milestones in your photography life.

SIDE LIGHTING

Side lighting is when the light is coming at your subject from the side. Light coming in from a window will side light your subject, as will the light in the late afternoon or morning. Side light can be tricky, because it's easy to end up with one side of the face lit well and the other too dark. If you can control your subject, you can have him tilt his head toward the light to fix that issue. Good luck getting your two-year-old to give you that perfect head tilt! Side lighting is what you see in famous paintings. It skims over a person's face, highlighting the soft curves of facial features, and adds depth to your images. This type of light takes practice. When you get it just right, it's fantastic!

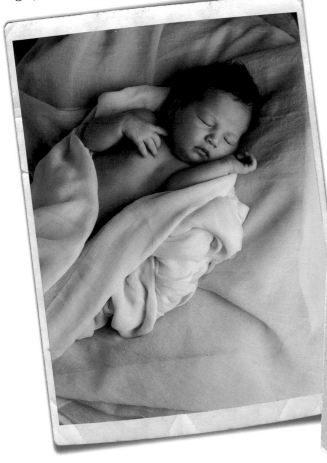

FRONT LIGHTING

Front lighting is light that falls on the front of your subject. If your light source is at your back, then your subject is being front lit. This type of light is even and a bit easier to work with than side lighting. It has less dimension, though, and you have to watch out for squinty eyes if it's very bright. If the front light isn't overly bright, it can cast a lovely, smooth light over the face of your subject.

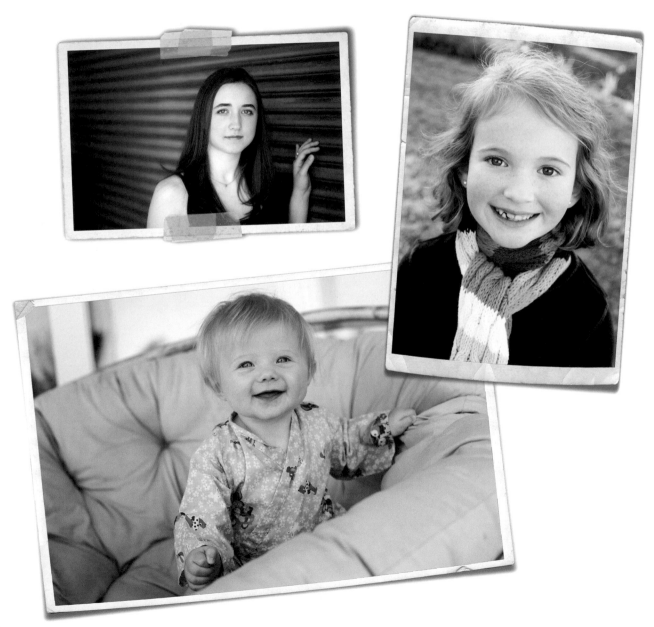

TOP OR BOTTOM LIGHTING

In most cases, the most unflattering light comes from the top or the bottom. It casts dark shadows around the eyes and under chins and creates bright spots on top of heads. Imagine holding a flashlight above your head or under your chin...not pretty! Barring some purposeful, creative application of top or bottom lighting, this will likely not be your favorite lighting direction. Bottom lighting is less common, as most natural light falls from above or from the side. Top lighting is most often encountered outside during the middle of the day or indoors with overhead lighting.

Yuck! The harsh overhead sun is making her squint and casting harsh shadows on her face.

The bottom lighting in this image works because it shows the viewer that the table was lit and casts a gentle glow on their faces. This is what I mean by a "creative application." Here the light helps tell the story of where they are and what they are doing.

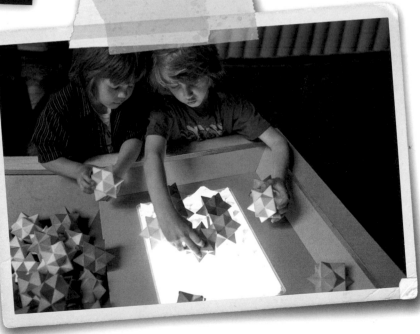

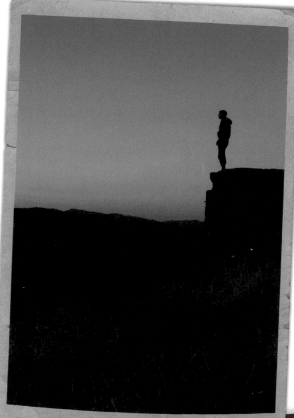

BACK LIGHTING

Backlighting can deliver dramatic silhouettes or skim along the edge of a child's hair, making it glow. If the light behind your subject is bouncing and reflecting all around (like in the morning) you will get a shot like the one below of the three sisters. Morning light is soft and allows you to backlight and still have light on the faces. The difference between the light behind and the light in front is not as extreme as it is later in the day. Later in the day, when the light coming at your subject from behind is significantly brighter than what is in front, you will be able to easily create a silhouette. To learn more about how to create silhouettes (or prevent them) by using the specialty metering modes on your camera, you can read about metering modes on page 60. Knowing how to use the various metering modes will help you control backlighting and get the kind of results you were imagining.

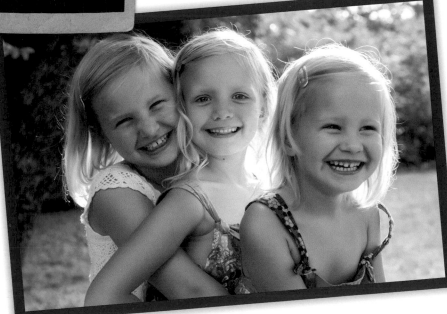

WHAT I LOOK FOR

My favorite time to photograph outdoors is early in the morning. My second favorite time is later in the day before the sun sets. I always look for bright light with a little bit of cover. That little bit of cover can be a porch, a tree or anything that very lightly shades the subject but allows plenty of light to come in from the side and the back. The little bit of cover keeps people from needing to squint their eyes and it helps you avoid the split lighting look that happens when you are in the direct sunshine.

When I shot this image it was a bright sunny day, but on one side of the bounce house it was shady. So, I went to that side and waited for them to come peek out at me. By switching to the shady side, I avoided harsh shadows and overly bright direct sunlight on their faces.

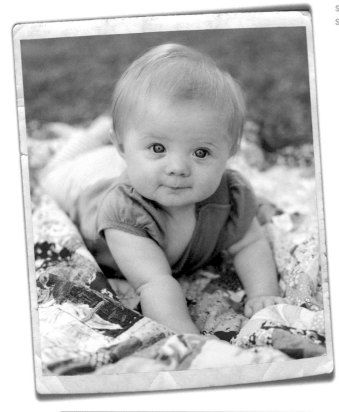

A simple set up...a beautiful baby enjoying the late afternoon light in the front yard. The sun was low enough to not cast harsh shadows but not so much that all the light was gone.

This image was taken in the late afternoon. I had him walk into a shaded spot under a tree but the light still came in from above and behind and added some pretty light into his hair and on his shoulders.

Instead of trying to capture your little one's Halloween costumes inside, make use of the last bit of daylight before they head out for trick-or-treating and have a little photo shoot outside. Depending on the light, you might need to raise your ISO to avoid using your flash.

If your children are early risers, make the best of it. Try some outside shots! If you live in a hot climate, this is also a good time to shoot because it will be much cooler first thing in the morning.

HOW TO PRACTICE

- Experiment and play! If it doesn't work the first time, try again!

- Be a student of light. Watch it and appreciate it even when you don't have your camera in hand. Watch how it shines over the water or casts shadows as it comes through the windows of your house. Notice how it falls across faces and reflects in people's eyes.

- Photograph early and photograph late and compare the results.

- Look around your house for good sources of bright, open shade. A covered porch? The side of the garage? When is your yard shady? Morning or afternoon?

- Find a friend to model for you and try putting the sun behind her, in front of her and to the side. Notice the changes.

CAPTURING SUN FLARE

SOMETIMES WHEN YOU ARE SHOOTING TOWARDS THE SUN, it can create something called flare in the photograph. You can avoid flare by using a lens hood. Some lenses come with a screw-on lens hood. It's usually black plastic and goes on the front of the lens to help shade it and reduce flare. Or, you can also embrace sun flare and use it to create some very cool images. To experiment with sun flare, place your subject in between you and the sun and allow the sun to peek out around her. You will find that this experiment works best during the late afternoon when the sun isn't directly above.

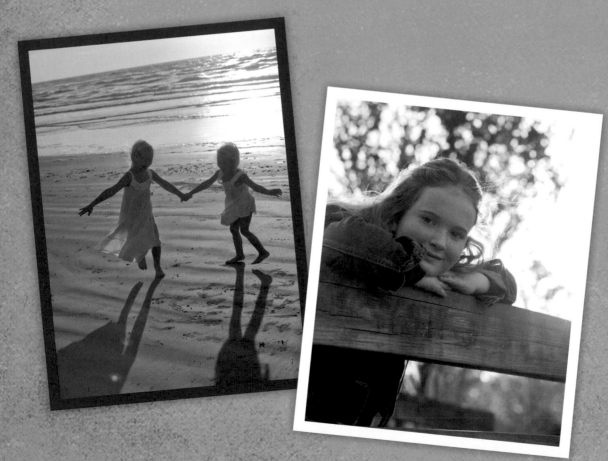

If you have your f-stop set at a high number (small opening), your sun rays will be sharper and more defined. A low number f-stop (large opening) will produce a softer, less defined area of flare. Try it both ways and see what you like!

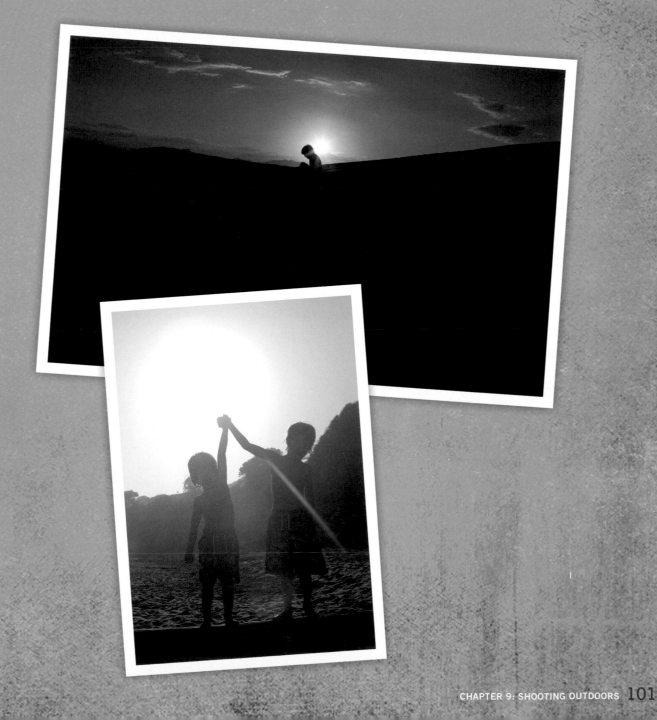

CHAPTER 10
Lenses 10

"LOOK AND THINK BEFORE OPENING THE SHUTTER. THE HEART AND MIND ARE THE TRUE LENS OF THE CAMERA." – Yousuf Karsh

While there are many opportunities in life to save a buck, buying lenses for your camera is not one of them. Great lenses cost money, but a higher quality lens can make a huge difference in your photographs. Lenses are priced based on the quality of the lens, its materials (the glass, metal or plastic it's made of), its technical specifications and its capabilities.

So, what makes a lens a great lens? What should you be looking for when buying a lens? Which lens is right for what you are shooting? To answer these and other questions, let's start at the beginning.

WHAT IS FOCAL LENGTH?

Lenses are designed in various focal lengths. The focal length of a lens tells you how much magnification that lens will provide. On your lens you should see a number or numeric range like 50mm, 18-55mm or 70-200mm. There all sorts of lenses out there, so yours may have a different number or range. The number is usually displayed on the front of the lens (take off your lens cap and look) or on the side of the lens. You should see something like this:

Canon 18-55mm F3.5-5.6
or
Canon 85mm F1.8

The first part is the maker of the lens (Canon, Nikon, Sigma, etc.). The mm number or range will be next. After that you should see an f-stop number or f-stop number range (as in the first example). The f-stop number tells you what the widest f-stop opening is for that particular lens. If there is a range, it tells you the widest f-stop changes depending on how zoomed in or out you are. A low mm number or focal length is more zoomed out, which is also called a wide angle lens. It shows you a wide angle of view including lots of

periphery. As the numbers get higher, the lens will be more zoomed in. You will lose more of your peripheral view and have a narrower angle of view (see diagram on the lower right).

In the two images below, neither I nor my model moved. The only thing that changed was my focal length. In the upper image, I zoomed in (using a higher mm number). Notice how her face and arm look more natural and not distorted. In the lower image, I used a wider angle lens. As you can see, her arm looks pulled down and distorted and her face looks stretched forward. When you consider each image and how it corresponds to the illustration on the right, you will see that as you shorten your focal length (smaller mm number) you get a wider angle of view, which adds some distortion and "bend" to the image. When you zoom in or use a higher mm number lens, you'll notice that the focal plane flattens out and there is less distortion.

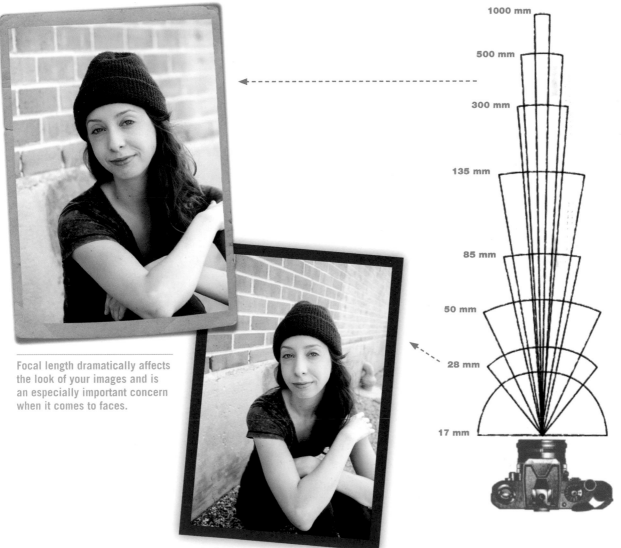

Focal length dramatically affects the look of your images and is an especially important concern when it comes to faces.

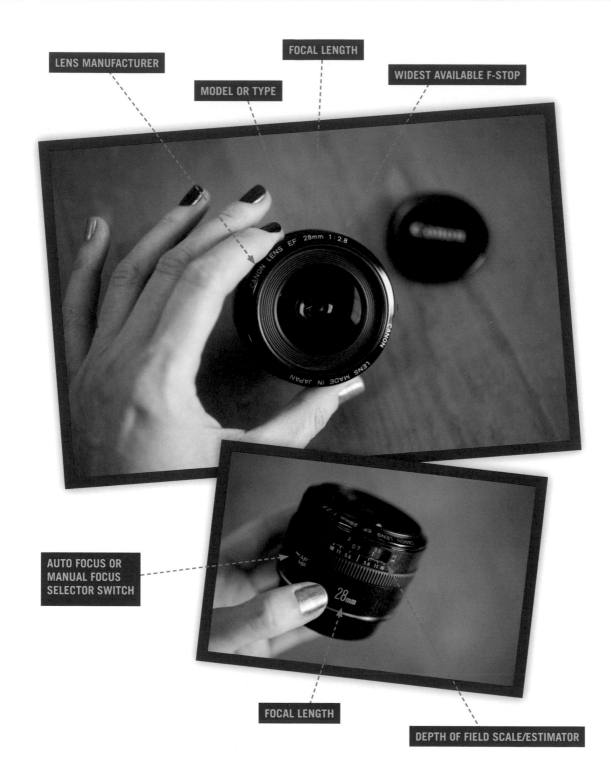

LENS MANUFACTURER

MODEL OR TYPE

FOCAL LENGTH

WIDEST AVAILABLE F-STOP

AUTO FOCUS OR
MANUAL FOCUS
SELECTOR SWITCH

FOCAL LENGTH

DEPTH OF FIELD SCALE/ESTIMATOR

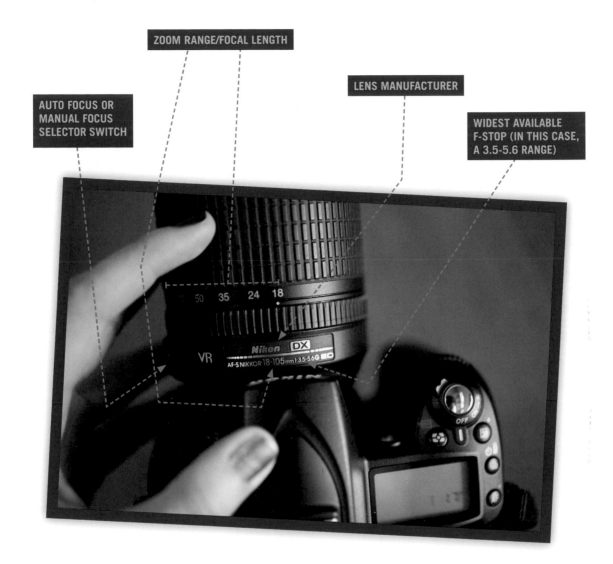

AUTO FOCUS OR MANUAL FOCUS SELECTOR SWITCH

ZOOM RANGE/FOCAL LENGTH

LENS MANUFACTURER

WIDEST AVAILABLE F-STOP (IN THIS CASE, A 3.5-5.6 RANGE)

Here are two different lenses. The left lens is a Canon EF 28 mm F 2.8. It is a fixed focal length lens (not a zoom). Fixed focal length lenses are also called prime lenses. All lenses are going to be a little different. Your Canon may have the numbers in slightly different places, but this should help give you an idea what to look for and where.

The second lens is a Nikon AF-S 18-105 F 3.5-5.6. It is a zoom lens so the numbers indicate a range (18-105 mm, for this example) rather than a single focal length number. Zoom lenses can have an f-stop range (like this one) or a single widest f-stop. It just depends on the lens. Take some time to study your gear and get to know its specifics.

WHAT DO DIFFERENT FOCAL LENGTHS LOOK LIKE?

Let's take a look at how focal length affects the look and feel of an image. In this example, I photographed a little doll using various focal lengths (as noted by the images). I started out using the "shorter" wide angle focal lengths and progressed up. I stood in the exact same position for all of the shots.

24 mm

35 mm

50 mm

90 mm

140 mm

200 mm

MORE ABOUT FOCAL LENGTHS AND FACES

Focal length is not just something that you consider when you need to zoom in on something far away or zoom out wider to capture a larger scene. Focal length affects the look of our images and this is especially important when photographing faces, as we saw on the previous page. In this example, I photographed the subject in the same way as I did the doll. In all three of these example images, the model and I stayed in our original places. All I changed was the lens' focal length (for my example, I used a 28 mm lens, a 50 mm lens and a 70-200 mm zoom lens). In the top image, I photographed her with a 28 mm lens. You can see how it bends and distorts her face, making her nose more prominent and her features more extreme looking. In the next image, I used a 50 mm lens. You'll notice that her face looks much more natural. Lastly, I photographed her at 70 mm. Of the three images, this last one is the most flattering. Her features are balanced and her face is not distorted at all.

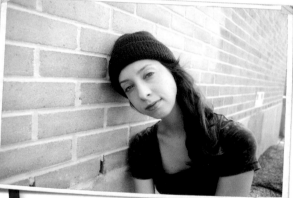

At 50 mm, her features look a bit more natural.

At 28 mm, her face is distorted making her nose appear larger and her face more angular.

The most flattering of the images is the last one, which was shot at 70 mm. All of her features are balanced and she looks like herself!

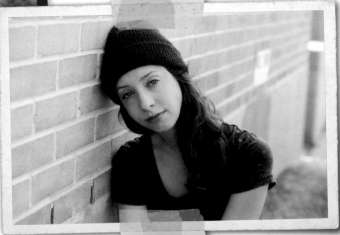

THE KIT LENS

The bad news for most people is that the zoom lens that shipped as a package deal with their DSLR is not a great lens. In fact, it's a pretty terrible lens with serious limitations. The biggest limitation is that to get a good shot in low light (i.e. pretty much anything indoors), you need a lens with a low number f-stop (a wide opening) like F1.8 or F2. The lens that ships with most DSLRs has 3.5-5.6 for its lowest (widest opening) f-stop range. At an f-stop of F5.6 you would need eight times as much light to take your picture as you would if you had a lens with an f-stop of 2.0. This will make it impossible to get a decent shot in low light unless you use your flash, which will completely change the picture from what you are seeing with your eyes. The other issue is that, in order to make the lens lightweight and cheap, the manufacturer has to sacrifice image quality. The kit lens will not be as sharp and the contrast may also be reduced. Basically, you end up with a great camera and a bad lens. You would be better off having a less sophisticated camera and a great lens.

If you have not yet bought a digital camera or are considering replacing the one you have, I would recommend not buying the kit with the lens included. Instead, consider buying the camera body alone and then choosing the lenses that suit your needs best.

Lenses can get really pricey. When you make your equipment wish list, allocate your biggest budget to the shorter focal length lenses (the 18-55 mm range). Consider replacing your kit lens with an upgraded version that has a low f-stop number, around 2.0 or 2.8. Tamron makes lenses for both Canon and Nikon cameras and they currently offer a 17-50 mm F 2.8 that would replace your kit lens perfectly.

When you go up in focal length (70 mm and up) the longer focal length itself will help blur out your backgrounds, so you don't have to spend as much money getting the lower f-stop capabilities on these lenses. The price difference between a 70-200 mm F 2.8 and a 70-200 mm F 4.0 will be significant, and the latter lens will be more than sufficient and will deliver gorgeous images.

MY RECOMMENDATIONS FOR A GOOD, WELL ROUNDED LENS SELECTION:

- Everyday lens: 17-50 mm F 2.8 (look at the Tamron lens I mentioned above for a less expensive version).
- Portraits and more: 50 mm F 1.8 (or 1.4).
- Sports, travel and distant subjects: 70-200 mm F 4.0.

IF YOU ARE CONSIDERING PURCHASING A 50 MM LENS:

- **50 mm F 1.8:** Fantastic place to start as a beginner, great learning lens, good for portraits, lower price tag makes it accessible (around $100-120).
- **50 mm F 1.4:** Gives you more light, good for portraits, higher price tag makes this lens more suitable for the serious amateur (around $400).
- **50 mm F 1.2:** The maximum amount of light available, good for portraits, much higher price tag, considered a professional's lens (around $1600).

THE "NIFTY-FIFTY"—WHAT IS A PRIME LENS OR FIXED FOCAL LENGTH LENS?

A prime lens is one that doesn't zoom in or out and has one focal length, a 50 mm for example. Prime lenses are a great choice because they are usually small, lightweight and sharp and are available with wide f-stop openings like 1.4, 1.8 or 2.0. They will allow you to shoot in lower light conditions (i.e. indoors) and allow you to completely blur out your background (see page 78). Their simplicity allows you to spend your time learning the f-stops and your other camera controls while also not having to mess with your zoom. You become the zoom and just walk in closer or back up as needed.

Canon makes a 50 mm F 1.8 that is inexpensive and simple to use. It would be a fantastic choice for portraits. The small price tag makes it a very affordable learning tool, too. If the 50 mm forces you to back up too much and you want a wider angle of view, consider a 35 mm F 2.0. If you get really serious about your photography and want even more light at your fingertips, you can look at the Canon 35 mm F 1.4 or the Canon 50 mm F 1.2 or F 1.4. Be warned, that extra f-stop is going to bump the price of the lens up substantially as those are in their L-series (professional line up) of lenses.

BRAND NAMES?

Not all lenses will work on all cameras. You will want to be sure that the lens you buy is compatible with your make and model of camera. Nikon lenses will not work on Canon cameras and vice versa. Tamron and Sigma do have lenses that fit both Nikon and Canon cameras, but you need to be sure to get the right Tamron or Sigma for your camera. A good camera salesperson will know what fits what. Tamron and Sigma lenses will also save you a significant amount of money, so they are worth a look when it comes time to do your lens shopping. There are a lot of places to shop for equipment. My online favorite is BH Photo Video

www.bhphotovideo.com. In my experience, their staff is knowledgeable, not stuck up (or condescending to new photographers) and willing to walk you through your purchasing options. They also have competitive prices and a full inventory. If you have a good local camera shop, it would also be a good resource. Shopping online is convenient, but it's also nice to actually test out real gear, hold it in your hands and see how it feels.

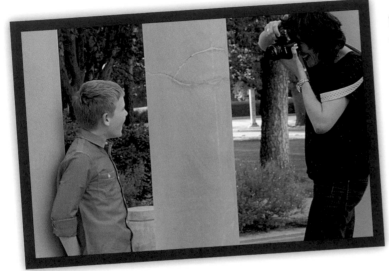

WHAT LENS TO USE AND WHEN?

When you reach for your camera bag you need to ask yourself, what is the story? The answer to that question will help you pick which lens is best for your subject. If you are shooting a sporting event or are far away from your subject, you will want a lens that allows you to zoom in on the action. If your subject is right in front of you, you may need something with a wider angle of view.

GENERAL GUIDELINES:

- **Sports and far away scenes:** You will need a longer zoom lens. Look at something in the 70-200 mm F 4.0 range.
- **Portraits:** You will want to use something in the 50 mm and up range. A fixed 50 mm will be a great choice. If you end up purchasing a 70-200 mm for sports, you could also use that lens for portraits, though you will have to back up a little.
- **Close up scenes:** An 18-55 or 17-50 mm lens would work well for things that are happening close to you. You will want to look at replacing the kit lens that you may have with one that has a wider f-stop opening, especially if you plan to photograph indoors. Look at Tamron or Sigma if the Canon or Nikon lenses in this range are too pricey.

WHAT'S IN MY BAG?

I do about half of my shooting in the studio. When I'm there, I use almost all fixed focal length lenses. When I am out in the world chasing my kids around, I use both zooms and fixed focal length lenses. Here's what I love and use every day.

CAMERA
- Canon 5D Mark II

LENSES
- Canon 50 mm F 1.4
- Canon 85 mm F 1.8
- Canon 70-200 mm F 2.0
- Canon 24-70 mm F 2.8

YOUR BABY'S FIRST YEAR

YOUR BABY'S FIRST YEAR OF LIFE can fly by in a blur. Here are my favorite ages and stages to photograph, along with some suggestions for how to capture each one.

WELCOME TO THE WORLD! BABY'S FIRST DAYS

If you are having your baby in the hospital, go easy on yourself. It's difficult to shoot in hospitals. They are chaotic and have busy backgrounds and usually not very much light. You will probably end up using your flash (make sure to read through the chapter on how to diffuse your flash).

Tips for shooting in the hospital:

- If your hospital room has a window, use it. Open up the blinds and shades and see if you can let more light in. Turn on the lights in the room as well.
- Make the background of your photos blurry using shallow depth of field (see chapter eight on f-stops and depth of field) to help minimize the distracting equipment and such in the background. Another way to minimize a busy background is to get closer and crop it out.
- Review chapter eleven about shooting indoors.
- Keep your eye on your shutter speed (keep it above 1/60, see chapter six on shutter speeds) to ensure your pictures aren't all blurry from camera shake.
- Don't be so wrapped up in capturing the images that you miss the moments.
- Hospital images look great in black and white.

Enlist a helper because you and your birth partner are likely to be busy. When you or your helper are photographing, try to capture moments like cutting the cord, putting your baby on the scale for the weight and making the footprints and details like your baby's tiny hands and precious face. Try to capture the day in a series of storytelling images.

NEWBORN

The first weeks at home will be a blur of feedings, crying, visitors and sleeplessness. Try to carve out some quiet time to capture your baby while he is still this small. I recommend photographing babies within the first two weeks. One easy way to capture them at this stage is to set up a little scene by a window with a blanket and a bassinet, pillow, chair or couch (basically some sort of comfy spot for them to lie on). When your baby is awake dress her in whatever you

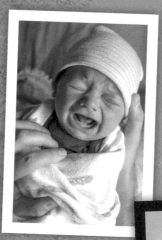

would like, or leave her naked, which is always super cute. Feed her well, and when she starts to drift off to sleep, place her in your little homemade studio and shoot away. If you have everything set up beforehand this can be pretty easy and simple. Make sure to read through chapter eleven on indoor photography and window light before you try this out!

Some other great moments to capture would be bathing, playing in the crib and lying in the quiet alert stage. Try to capture the details like tiny hands, the swirl of their hair, little feet and even the crying face.

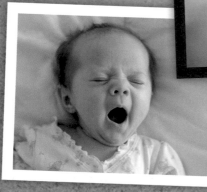

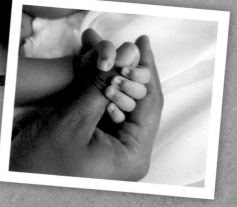

There are few things in life nicer than a newborn smiling in sleep. Catching that amazing moment requires patience, luck and maybe a sweet whisper in a little ear while he dreams.

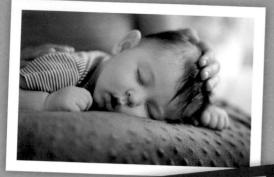

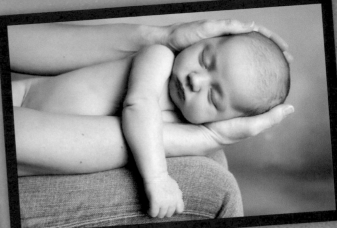

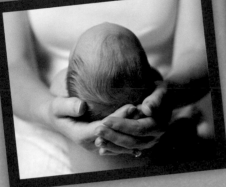

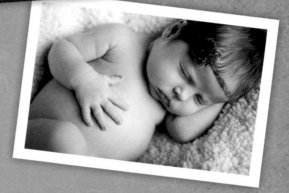

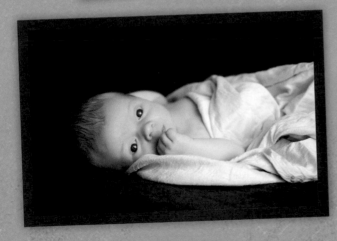

Keep the background simple. A black or white blanket spread out over some pillows and placed by a bright window is all you need.

Clothing can swallow newborns. If you opt for an outfit, make sure it fits snugly. It'll look much better in your photographs.

TUMMY TIME, 4-5 MONTHS

At this stage, your baby's personality is starting to emerge. He even smiles at you! Try to capture some of these new expressions with close ups of your baby's many faces. Find a window and lay your baby on a blanket next to the window and shoot away. Use your own big smiles and sweet words to bring out his. You can use toys like rattles, squeakers and feathers to get him to look at you.

This is a great time to get shots of your baby on her tummy. To get the very best shot, you want your baby to have her head up high and strong. If her head isn't high enough, you'll just see the top. If she gets frustrated trying to hold her head up, just try again on another day. You might also try propping her up on a boppy pillow or on someone's shoulder to give more support.

As with all of your baby's stages, the key to a great photo session is to make sure that your baby is well fed, in a clean diaper, comfortable and rested. If she is unhappy, it will definitely show, so try to plan your shoot for a time when she is happy and all her needs are met.

Little details...

Does your child have a special love object or favorite toy?

SITTING UP, 6-9 MONTHS

This is one of my very favorite times to photograph babies! They are full of personality and will usually give you big smiles. Now that your baby is sitting, clothes will fit better and fall more naturally, giving you more options for outfits. Don't rush to cover up too much of your baby though, because this is a great time to capture those chunky little arms and legs. Try to capture this stage before she starts to crawl because, after that, you're going to be chasing her for a while.

Find a window, open doorway, covered patio or other source of soft bright light, position your baby and shoot away.

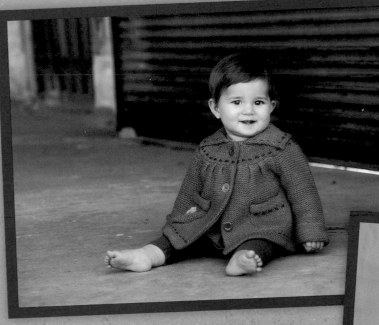

Already crawling? Try to capture it! Have a helper put your baby in front of you about six feet away. Get ready with your camera, tell the helper to let the baby go and catch her crawling towards you.

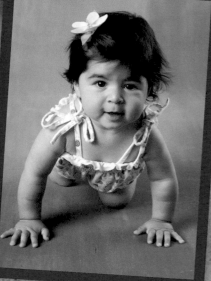

STANDING UP, 10-12 MONTHS

Now that your baby can pull up and stabilize herself on tables and chairs, make sure to grab some shots of her standing up tall. Clap for her and cheer her on, and she'll likely reward you with a proud smile. Take an ottoman, stool or walking toy and place it near the window, or take her outside into the shade. Try to capture those precious first steps by enlisting a helper. Have Dad hold your baby's hands or let her use his legs to help her stand up.

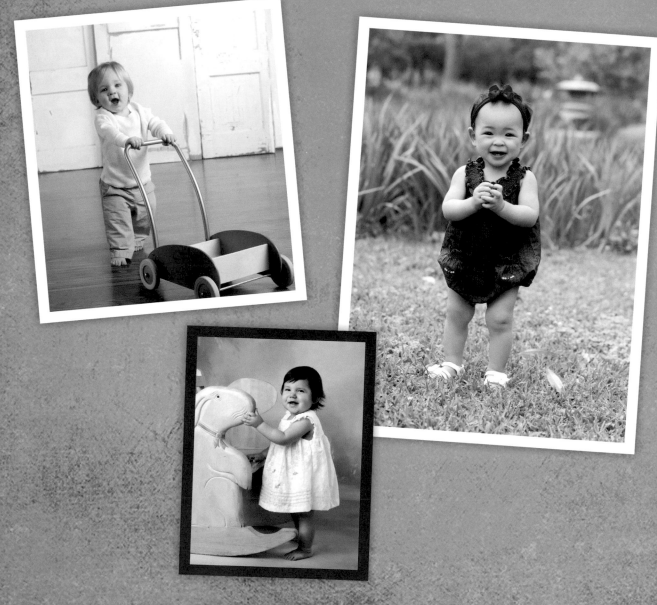

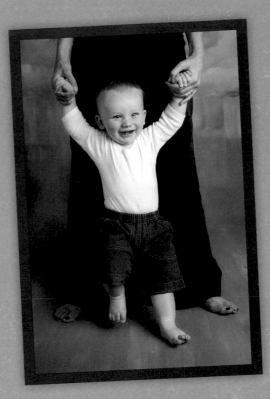

The more mobile your baby becomes, the harder it is to get the shots that you want. By the time you have everything ready to go, they're across the room. Be as ready as you can be, and keep the photo sessions short. It may take a handful of tries to get the shot you are hoping for but know that you aren't alone in the quest. Babies on the move make challenging subjects even for professionals. Find something to help occupy your baby for a short time. Wooden blocks work wonders! Is there a chair or small step stool that she can interact with? Try setting everything up while she's napping, and be ready for a mini photo shoot when she wakes up fresh and happy.

My son's very first steps, a bit blurry but priceless!

CHAPTER 11
Shooting Indoors 11

One of the primary complaints people have when they begin photographing is that the shots they take indoors turn out dark, yellowish and blurry. Truth be told, indoor photography can be very, very challenging. Generally speaking, the quality of most indoor light is bad. It's a funky color (images look orange, green or even blue) and there's usually not enough light to begin with. The light indoors looks flat as well, meaning it doesn't have any direction, which is one of the things that makes great lighting great. Don't fret! You can improve the quality of your indoor photography and be less frustrated by following a few key tips.

KNOW YOUR ISO

You absolutely have to take the time to know how to adjust your ISO. This is critical. Please take the time to really grasp basic exposure and ISO control (page 52). Your ISO controls how sensitive your camera is to light. Remember, higher number ISOs (800, 1600, 3200 or 6400) make your sensor more sensitive to light, allowing you to do more with what little light you have available to you (think: recital or something indoors). Low numbers (100, 200) work in reverse. They desensitize the camera's sensor allowing you to capture shots in very bright conditions (think: the beach at noon). In order to capture images indoors, you may need to adjust your ISO to allow your camera to be more sensitive and make better use of the limited light that you have available.

The only way you are going to get a cute shot of your kids in the bathtub is to maximize the tiny amount of light that might exist in your bathroom—unless you are one of the lucky few who has a wall of windows by the tub.

TURN OFF YOUR FLASH

If your camera automatically pops up the flash when the light is low, you need to find the directions in your manual to override the auto flash. This is also helpful when shooting indoors around reflective surfaces, like glass. Flash can reflect on glass and in mirrors and ruin an otherwise great image. There are times when you have to use your flash, and we'll go over how you can modify your flash to soften the output a little later. For starters, try raising your ISO and using the widest f-stop that you can.

Glass and flash don't mix well. To get shots like these, you have to turn off the flash.

When you use the existing light in the room, your background will look better. Flash makes your backgrounds dark. When you have some window light, make use of it.

WATCH YOUR CAMERA'S SHUTTER SPEED

Is this what your indoor shots look like? Yuck! Let's talk about what's happening here. This is one of the most common mistakes one can make. The bottom line is that your camera needs light to make an image. It's going to try to get light any way it can. When you shoot in the automatic mode and there isn't enough light, your camera will slow down the shutter speed in order to gather up more light. When the shutter slows down below 1/60th of a second, you get motion blur from even the slightest movement.

SHOOT WITH A LENS THAT HAS A WIDE APERTURE OPENING OR F-STOP

Make sure to review the information about depth of field and controlling your f-stop (page 78). This is the second critical piece of the puzzle. The wider the f-stop, the better. The difference between most F 3.5-5.6 kit lenses (the ones that ship with the camera) and an F 1.8 lens is huge. It will make all the difference in your indoor shots. When you have a lens with a wider f-stop opening, you are able to let more light into your camera, which allows you to shoot with less light. If you find that most of your shooting occurs indoors, you will want to seriously think about upgrading and purchasing some lenses that will make shooting indoors something other than an experiment in frustration.

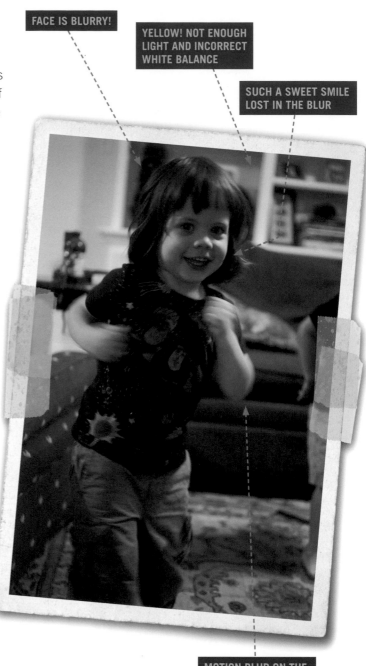

FACE IS BLURRY!

YELLOW! NOT ENOUGH LIGHT AND INCORRECT WHITE BALANCE

SUCH A SWEET SMILE LOST IN THE BLUR

MOTION BLUR ON THE HANDS AND ARMS

FIND THE LIGHT

Walk around your house and look for the brightest spaces. Where are the windows, doors that can be opened or covered patios? Can you open the drapes? Whenever possible, move your subjects into the well lit areas.

Here is an example of a shoot that I did inside of a home. I scouted the house first to find the brightest spots, which ended up being the living room, the baby's room and the bedroom. The bedroom was the darkest of the three. We opened the drapes (a simple, often overlooked tip), positioned the baby closest to the light near the corner of the bed and turned her body towards the light.

ISO: 1250
SS: 1/160
f 5.6
70-200 mm lens @80 mm

In her room, I opened the blinds up and put her in the brightest spot in the room, which was right at the edge of her crib. I positioned myself in between the windows and her crib, being careful not to cast a shadow on her.

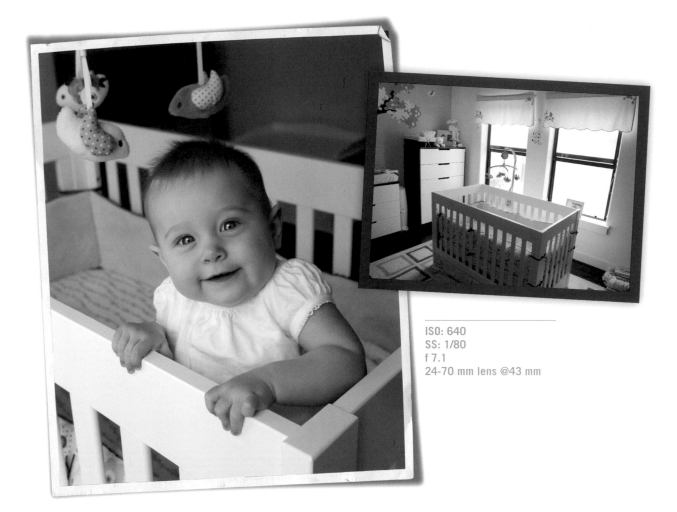

ISO: 640
SS: 1/80
f 7.1
24-70 mm lens @43 mm

Most houses are dark. In my house, I have three places where I can shoot. You need to take the time to explore your house and find the best spots. Look for rooms with windows or doors that can be opened up to allow more light. Pay attention to the light at different times of day: is it brighter or softer at one time of day versus another? Rooms that are white or light-colored will work the best.

Lastly, we set up in the living room. This living room had a great big window, which is a photographer's dream. If the light coming in the window is spotty or too intense, window sheers will solve that problem. You may also notice that the light is better in the morning versus the afternoon, or the reverse. While shooting here, I placed myself between her and the windows. This room had the most light of all the rooms.

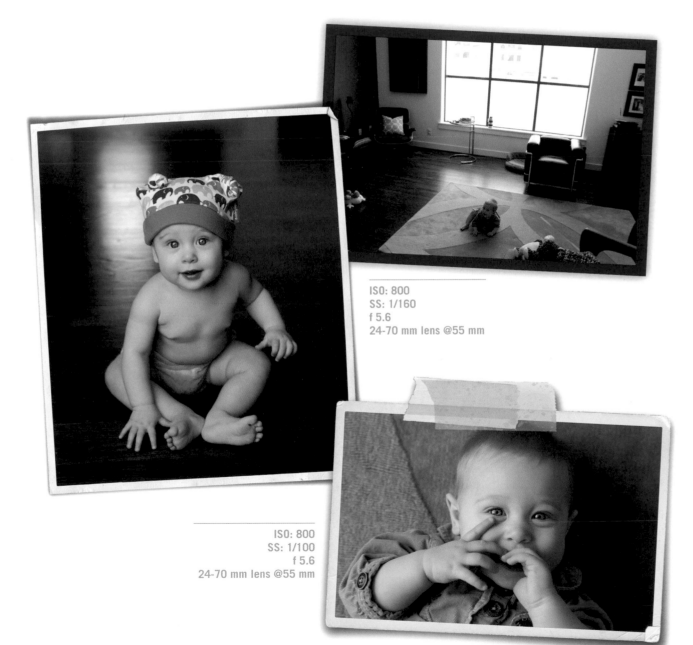

ISO: 800
SS: 1/160
f 5.6
24-70 mm lens @55 mm

ISO: 800
SS: 1/100
f 5.6
24-70 mm lens @55 mm

WINDOW LIGHT

Window light is one of the most beautiful light sources that you can find. It is soft, indirect and bright. At certain times of the day, the light coming in your windows may not be soft or indirect, so you'll want to look at it carefully. If your windows aren't the best source, you might have beautiful light coming through a doorway, sun porch or even an open garage door. Once you find a good spot, all you need to do is move the action there. The action may not be moveable, but, whenever possible, a simple set up like this can give you fantastic results. Here are some examples of a simple window light set-up.

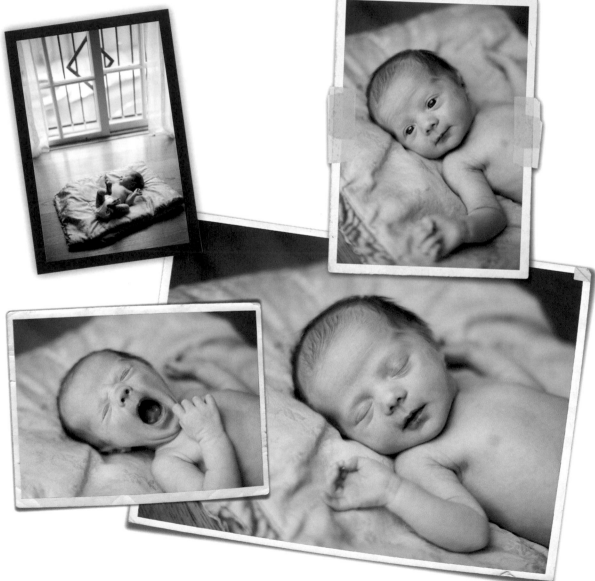

Just like when you're shooting outdoors, when posing someone by the window you need to watch the angle of the light. If she turns too far away from the light, you may get a dark shadow on one side of her face. If you can, direct her to turn into the light more or, in the case of a baby, just tilt her into the light a little more.

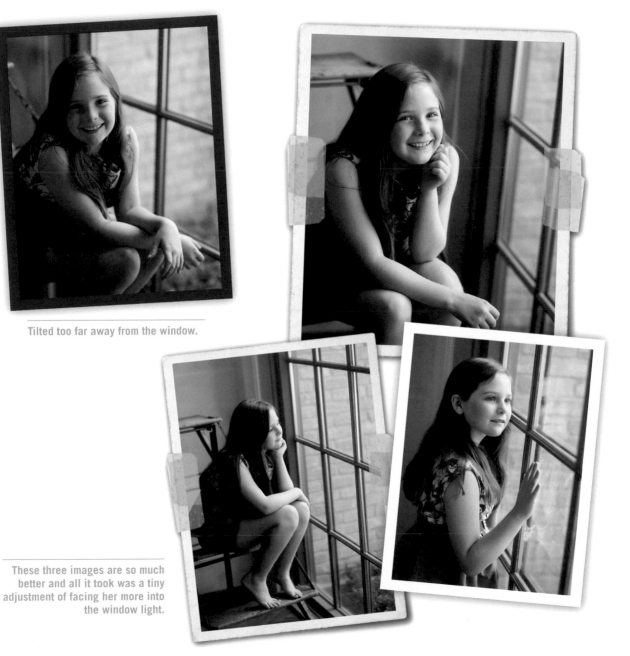

Tilted too far away from the window.

These three images are so much better and all it took was a tiny adjustment of facing her more into the window light.

These four images were all taken indoors using window light. The top left was set up just inside a front door. The top right is near a window (on his left, see the reflection in his eyes?). The bottom left image was taken with the window at her left. For the bottom right image, I spread out a white blanket on the floor next to a window. Now it's your turn. Walk through your house and find the light. Where are the windows? When does the best light appear and in what rooms? Can you open blinds and drapes to allow more light in?

HOW TO PRACTICE

- Find the brightest spots in your home and, when possible, move the subject to the light.

- If the light coming in a window is too harsh, try closing the drapes or blinds a little. This is a situation where sheer white window panels are perfect. Use them if you can to diffuse the light coming in through the windows.

- Experiment with positioning your subject, and angle him in various ways in relation to the light source. This is one of those times where your wiggly toddler may not be the best learning subject. Ask your spouse, friend or older child to model for you while you practice working with window light.

- Upgrade your lens to one that has low number f-stops.

- Play with your ISO and be able to control it quickly when you need more light.

FLASH TIP
DIFFUSE IT!

LET'S FACE IT. There isn't always a beautiful window around, and sometimes you're stuck inside a dimly lit room. Sometimes there is no light at all! So, what do you do at night, inside a darker home, at a recital? When your only option is to use your flash, there are ways to help make the flash light softer and more appealing. Flash usually looks harsh. It bleaches out skin tones, throws your background into dark shadow and creates hard shadows behind people. The solution to this is to modify your camera's flash by adding something called a diffuser.

There are many different types of flash diffusers. Generally they involve a piece of semi-opaque, white plastic that goes in front of the flash to diffuse and soften the light. I have tried all different brands of diffusers. My favorite diffusers are made by Gary Fong. There is one made specifically for the built-in pop up flash on DSLR cameras called the Puffer. There is also one for the built-in pop up flash on point-and-shoot cameras called the Delta. If you use an external flash (one that attaches to the top of your camera and is not built-in), you would use the model called the Lightsphere. All of his diffusers are available for sale on his website, *www.garyfonge-store.com*. Diffusers are a simple and inexpensive way to make an instant improvement in all of your flash photography.

Here are some examples of pictures taken using the camera's flash and no diffuser, and then the same scene shot with the diffuser on the flash. This series of images was taken in my living room at night. The only available light was the living room overhead light.

FLASH

DIFFUSED FLASH

This image was shot without a diffuser. Notice how the skin tones are bleached out and how the flash hit the pillow and created a harsh shadow onto his face.

Here he is in a similar position but this image was shot using the flash with a diffuser. The light is so much softer!

In addition to being harsh, the flash also creates a flat look.

These images were taken using the diffuser. Notice how much softer the shadows and skin look and how the background has not gone completely dark.

CHAPTER 12
Expressions

"IT'S ONE THING TO MAKE A PICTURE OF WHAT A PERSON LOOKS LIKE, IT'S ANOTHER THING TO MAKE A PORTRAIT OF WHO THEY ARE." – Paul Caponigro

The thing that makes a portrait truly great is the subject's expression. When you can see a person's true spirit shining through, that is the magic of portrait photography. What's especially amazing about photographing children is that, when they're allowed to have fun and play, they can't help but shine in front of the camera!

The tricky part about getting great expressions is that most children cannot fake a good smile. You have to coax the *real* expression out of them. For the youngest of subjects, you cannot expect them to perform on cue. You have to find ways for them to have a good time and smile. To make this more challenging, you have to do it while you have the camera ready.

The great news is that, as parents, you usually know all the little tricks to get them to smile. You know the goofy jokes, funny noises and crazy expressions that get them laughing. To get the best shots, you have to be willing to be silly and find fun ways to get your shots. If you can master the art of silly and cultivate a bit of patience, you will be richly rewarded in your photographs.

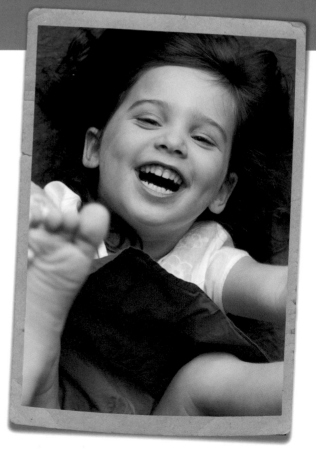

One of the games that I like to play with toddlers and younger children is to ask them to make faces for me. I'll say, "show me a sad face" and then, when they do, I'll pretend that they're making me sad. I'll ham it up for them, looking sad and fake crying. Try something like "I bet you can't be really loud" and see if they'll scream. That's always good for a laugh. Ask for a mad face or ask them to growl. Jump back pretending to be afraid, and they'll usually laugh. That's when I take my picture. I'll get the silly, sad and mad faces too, of course! The idea is if it can become a fun game for you and them, you're more likely to get the real smile. Avoid making it a chore where you're making them "Sit here!" and "Be still, smile!" Say no to "say cheese!"

Everyone loves a big, silly smile. An awesome smile on a child is infectious. It makes you smile in response. The thing is, not all kids are smiley. Some of our kids are shy, introverted or serious. I want the serious, thoughtful faces as much as the toothy grins. When you look back on the images of your children years later, you'll appreciate more than just the smiles, too. Do your best to document the whole person and include the crying face, the mad face, the quiet reflective face and the proud face, as well as the smiling face.

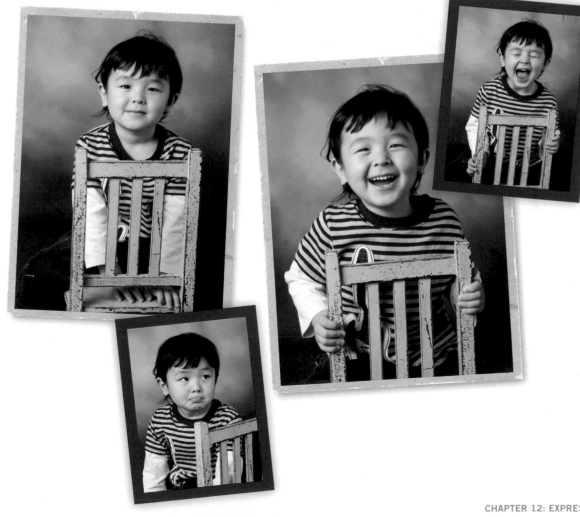

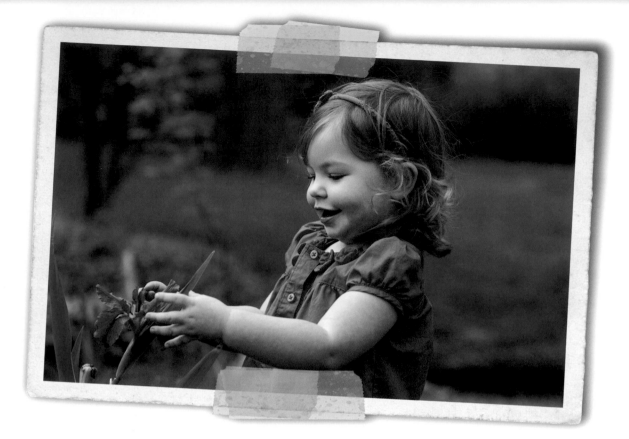

SIT BACK, OR INTERACT?
WHY STEALTH IS A GREAT SKILL TO HAVE AS A PHOTOGRAPHER

One of the things that I want you to change about the way you approach your photography is how much you purposefully interact and direct your photography efforts. Most people start off the photography process by telling their kids to "turn around, get closer, look here, smile!" Kids can become so conditioned by this that when they see a camera pointed at them, they immediately look, compose a terrible fake smile and say "cheese!" This is something that I want you to actively avoid. This is not to say that you don't ever direct your family, but rather that you have a nice balance between the candid shots and the crafted shots.

It goes something like this: You see your kids doing something cute, run for the camera and then start in with "hey guys, look this way!" or some other direction. They do so by delivering their very best (terrible) fake smile, get distracted from what they were doing, ask to see the picture on the back of the camera or just run away to avoid being photographed. The authentic moment is lost.

Instead, I want you to practice your best spy skills. Be stealthy, and try your hand at catching the action in a candid, non-intrusive way. If your subject is happily playing, sit back and try zooming in and catching a few shots. If she is truly invested in what she is doing and not noticing you, it gives you time to fool around with

your settings, try different angles and experiment. You are also likely to catch more authentic facial expressions this way. Try to learn your camera so well that you can sit by your child playing, talking and snapping away all at the same time. Your children will also appreciate this relaxed shooting style and reward you by not paying as much attention to your camera and just being themselves.

Here is a perfect example. I was sitting behind my two sons watching them as they sat next to each other and started to talk. I could have asked them to "turn around, lean in, look at me, smile!" but, instead, I grabbed my camera and just snapped them as they were. They talked for a little bit. The younger one felt a surge of love for the older one and gave him a hug. Then, in true form, it turned into wrestling. This little series is so much more "them" than it would have been had I intervened.

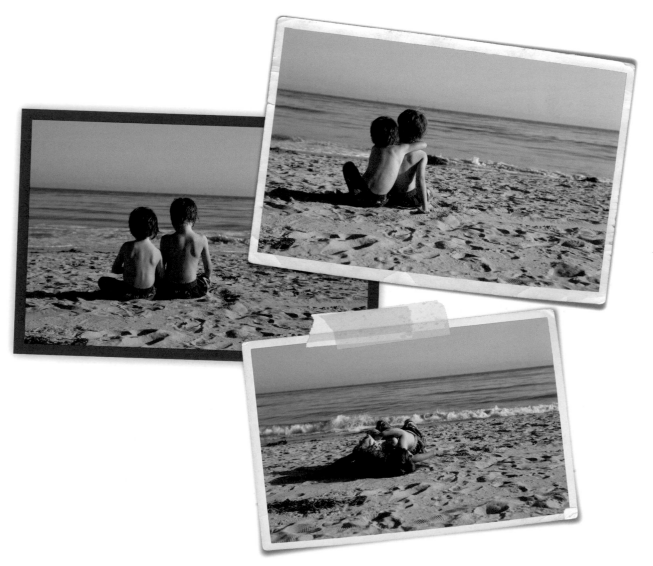

Let go of the idea that a great shot means someone looking straight into the camera and smiling. Don't leave out the profile shots, the not-looking-right-at-you shots and try to catch a few I-have-no-idea-you-are-photographing-me shots. Over time, the candid moments combine with the posed moments to draw a subtle and dimensional story of the people you are documenting.

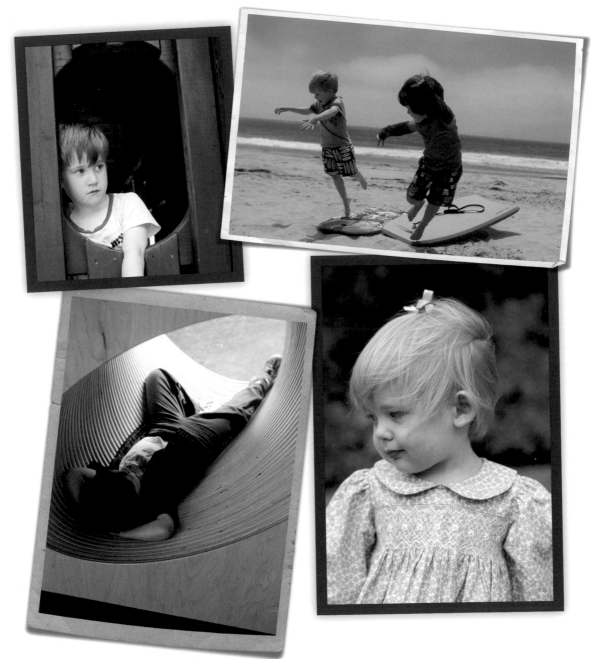

This won't be the last time you hear me say this, but the more you practice the better you will become. When your hands know your camera well, you will be able to catch better candids. The only way to get there, though, is to push through and practice as much as possible. Don't be discouraged by your first (or second or third) efforts, but keep working at it. You will see your images grow, change and be infused with the new candid energy you have been hoping to achieve.

WHEN YOU DO INTERACT...

Let them play! Encourage them to do something that they enjoy and be there to capture it. Play dress-up, do silly jumps into the pool, have them hold a puppet show, wear costumes (kids love costumes), let them jump on the bed or whatever makes for a good laugh and a willing subject.

Be silly! Make noises (gross ones work really well for boy subjects) and sing songs (really silly made up ones are best). Talk, ask questions and give them crazy answers. Play peek-a-boo, laugh and have staring contests. Try encouraging siblings to look at each other and say, "But, whatever you do, don't laugh!" Let down your own guard and just have fun alongside them.

Give a busy child something to do. Find a place with some pretty light (by a window maybe?), bring your child to the spot and give her a toy to play with to keep her occupied for a few minutes while you try to capture a few shots. This works especially well for babies who can sit but not yet crawl. Give her a stack of blocks, and clap as she plays. Older kids? Find something that they enjoy doing and try to set up a little scenario that will allow you to get some candids. Legos? Art projects? Let them make a mess! Catch your little reader while he's curled up on the couch with his favorite book or move the highchair close to a set of windows and let your little one practice picking up Cheerios for you.

NEVER UNDERESTIMATE THE POWER OF A SNUGGLE!

There's nothing like a little love to encourage some sweet smiles. Encourage kids to interact, lean in, snuggle up and give hugs. Interacting with each other takes the pressure off of performing for the camera. If hugs aren't their thing, try asking them to whisper in each other's ears, tell a story or tell each other a joke. Teenage boys may not be willing to snuggle up but they can play slaps, high five, have a staring contest or joke with each other.

Smaller kids will appreciate the hug from a sibling or their parents. The dynamic created when your subjects are not focusing on you but focusing on each other helps relax expressions and make everyone more comfortable.

Who doesn't love a little love?
You'll be amazed when you see
the power of a simple snuggle.

Be gentle. No picture is worth a fight. If the moment isn't right, just let it go and try on another day. When the moment is forced and strained it ruins the shot. You might get a decent shot, but you'll always remember what you had to do to get it. If being photographed becomes a painful experience for your loved ones, they'll not look back fondly on the images you do capture.

Be respectful. Not all kids are smiley and some are downright shy. No matter what you do, some kids won't play crazy games and some get embarrassed by all the craziness. You know your kids better than anyone. Meet them where they are and capture who they really are.

HOW TO PRACTICE

- Think about the things that your kids love to do. How can you set up something that will allow them to have a great time while being photographed?

- Know that sometimes photographing your own children is really challenging. When it gets to be too frustrating, put down the camera and wait for another day.

- Expressions change in a split second. Be patient. If your subject is staying put, keep your eye in the viewfinder, your finger on the trigger and wait. Be ready to snap when the moment is just right.

- Ask for your children's input. What do they want to do while you are photographing them? Maybe they have a fun idea for a shoot.

- A fake laugh is better than a fake smile anyday. An older child or teen may be able to indulge you with a fake laugh or two. Often, the act of doing this feels so silly and self-conscious that your subject will start genuinely laughing.

- Let loose, let go and have as much fun as possible!

BRINGING THE PIECES TOGETHER

YOU HAVE LEARNED SO MUCH! Let's take a look at a before-and-after that shows how some of your newfound skills work together to make a not so great image so much better. Let's take it step-by-step and bring all of the pieces together.

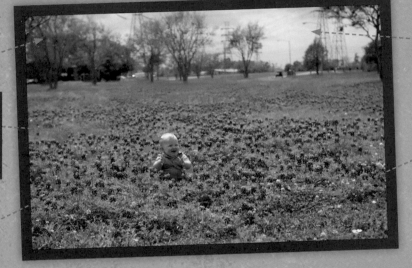

TOO ZOOMED OUT AND FAR AWAY

THE SUN IS DIRECTLY OVERHEAD MAKING A BRIGHT SPOT ON TOP OF HIS HEAD

THE SUBJECT IS TOO SMALL; YOU CAN'T EVEN SEE HIS FACIAL EXPRESSION

THE BACKGROUND IS DISTRACTING WITH ALL THE TREES, CARS AND WIRES

THE ANGLE OF THE SHOT IS TOO HIGH, WE ARE LOOKING DOWN ON HIM

WHAT'S WRONG WITH THIS PICTURE

The baby is lost in the image because we're way too far away. You can't see his expression very well. There are so many distracting background elements. This doesn't look like a lush field of Texas bluebonnets. What's that bright spot on top of his head? It's a bad time of day for shooting, because the sun is directly overhead. **Above all, the story is lost. Everything in this photo is of equal importance. Nothing stands out as the defined subject.** Everything is in focus, which makes it feel busy. Luckily, we can fix these problems!

THE FIX

Let's get closer and frame out the trees, the road and anything else that we don't need to have in the picture. Do this by stepping back and zooming in. You might use one of your longer lenses if you have one (like a 70-200 mm) or use a fixed 50 mm lens. If you're shooting with the kit lens, zoom all the way in.

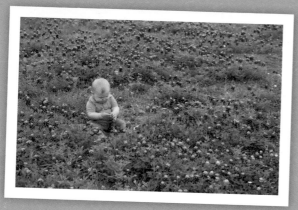

The first step was to zoom in with our lens and crop out the distracting background. The angle of the shot is still too high: see how the flowers look sparse, and we can't really see his face?

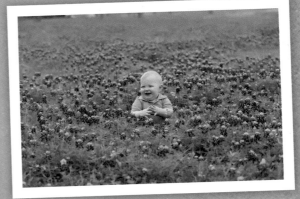

Get down on his level to create a better camera angle. When this was shot, the sun was going in and out behind the clouds. Waiting until the sun was behind a cloud made the lighting nicer. No clouds? That's OK, our other fixes will make a big difference regardless.

Now, use your f-stop controls to create shallow depth of field (blurry background) so that the foreground and background flowers get a little softer. Last step, let's get just a little bit lower and zoom in more. Now we've got it!

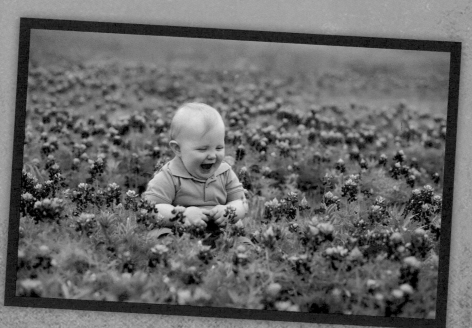

CHAPTER 13
BeProud—PrintIt! 13

Now that you have amazing images of your family, what's next? Your family can't appreciate their history if it's locked away on your computer's hard drive. Your young children can't be reminded of fun trips, awesome birthday parties and proud milestones if they're all stored on Facebook. Please, make the time to print out, display and frame some of your accomplishments! What better art can you find than the shining faces of the ones that you love. Here are a few ideas to inspire you.

I grew up with photo albums. They were binders (upon binders upon binders...) of 35 mm slides and lots of prints. I loved looking through them, even as a child. I can't say why I liked it so much back then but, now, I know exactly why. It shows me a side of myself that I can't remember. I see my children's faces in my own young face. I see my parents when they were my age. It makes me feel connected to them in a new way. I see my parents' questionable fashion choices from the 70s and wonder what my kids are going to say about my own in twenty years. Above all, I see that I was loved.

Every so often I'll hear someone say, "Well, I don't want my house to become a shrine to my kids!" My first thought is *Why not?* My favorite art in our house happens to be the images of my family. And, if you do collect and appreciate paintings and the like (we do as well), why not collect art *and* hang your own images? One is not mutually exclusive of the other. Hanging photographs of your family can be done in different and creative ways. There are so many options out there when it comes to printing and display. I wanted to share a few of my favorite ideas and highlight a few vendors who have amazing offerings. Hopefully this will get you inspired!

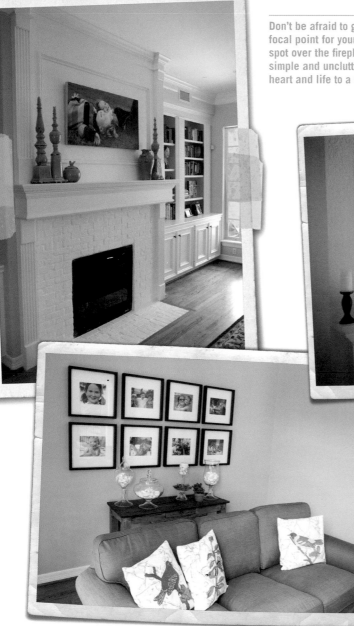

Don't be afraid to go big and create a true focal point for your home. Do you have a nice spot over the fireplace? Larger images look simple and uncluttered and can add so much heart and life to a room.

I really enjoy hanging our family images in the most lived in spaces in our home. I have a family image over our fireplace and another large image of my boys by the breakfast table. I love those two images so much and they make me smile every time I see them.

I love this idea for a display. It is a collection of eight framed 5x7s. The images are casual, everyday images, and the frames are simple, clean, store bought frames with mats. As the years go by, the images can be swapped out and new ones added to keep the display fresh and current.

Smaller prints can become interesting focal points as well. Look for ways to play off the color in your child's room by letting them dress up in something that coordinates well. Choose fun, playful images and print them for the playroom. Does your child's room have a theme? If so, set up a shoot that will complement the decor. Superhero costumes for superhero room? Ballerina pictures for a ballet theme? The key is to not be afraid to try something new and print it. Worst case scenario is that you don't love it and you try something else!

For more inspirational design ideas, visit the *Photography as Home Decor* gallery on my website, *www.farrahbraniff.com.*

Tiny prints can be really sweet. Create a fun collection of all sorts of memories and find a unique way to display them. Mix them in with other curios and souvenirs from your journeys as a family. Make sure and include a few of yourself. You are part of the story too!

IMAGE SLIDESHOWS

I am sure that, if given the time, I could learn how to create and edit my own videos. That being said, my learning to create and edit my own videos isn't ever going to happen. I have admitted that to myself and have turned over my creative video needs to the awesome folks at Animoto. All I have to do is pick my favorite images, size them correctly (they tell you how) and upload them to Animoto. They take your images and animate them into a very cool slideshow with amazing transitions, great music, titles and more.

I make Animoto videos of our vacations and the kids love to watch them over and over again. You can share the videos on Facebook or send them to loved ones. Are you the class parent this year, the team coach, the

troop leader? Animoto is an amazing tool for you brave leaders of kids! Did you take an awesome girls' trip and want to create a gift for everyone who was there? Animoto has you covered. They have four levels of membership and the first one is free. Give them a try to see what you think. Would you like to see my travel slideshows? Visit *www.farrahbraniff.com* and go to the *My Book* section for all sorts of extras, videos and more.

PROJECT LIFE BY BECKY HIGGINS

First things first, I am not an avid scrapbooker. I wish I was! I love everything about creating books, playing with paper, stickers, pens and embellishments. I have two half finished scrapbooks and a big plastic bin of supplies. The thing is, I'm busy. We're all busy, and it can be difficult to set aside the time needed to do all the custom work that scrapbooks can require. So, if you're frustrated with your half-full scrapbook, looking for something simpler or intimidated by the craftiness that seems to be needed for scrapbooks, I have a great solution for you! It's a simple, easy to use system of memory-keeping called Project Life. It comes with plastic pages and slip in journaling paper. Squares in the plastic pages fit prints or mementos. All of the pretty paper pieces are all coordinated and ready to go in a handy organized tray. If you can write out a few quick notes about the images on the page, print some 4x6s and slip everything into pages, that's all that you need to do! Even better, if you are a crafty goddess, you can customize the book and create your own inserts. If you are looking

for something different, you can buy all sorts of unique handmade pieces that fit the Project Life system off Etsy *www.etsy.com*. Don't want to mess around with paper and prints? Project Life has digital versions as well. For more on Project Life, visit *www.beckyhiggins.com*.

MAKING PRINTS

I've heard all sorts of conflicting opinions about where to get images printed. You may already have a favorite. Many people struggle to find a reliable, good quality printing source. If you want to easily create rich, well-printed, professional looking images then look no further than *MPix.com.* MPix is a division of Miller's Professional Imaging, which has been in business since 1939 and is one of the largest professional labs in the country. What that means to you is that the equipment, the technicians and the services are all professional grade. You can easily upload your images from the comfort of your own home with their simple to use software. They are lightning fast, too. You will be shocked at how fast you get your prints back.

One of the other things I really like about MPix is that they color manage your images. This means that they color balance the images before printing which results in the best and most natural color. You can also request that they don't color correct if you want to manage that yourself. Prints are just the beginning. You can upload images and create cards, calendars, framed prints, canvases, photo books, growth charts and so much more.

To ensure that your computer's monitor is accurately displaying color, you should invest in a color management tool like the Color Munki by X-Rite. It's very easy to use and works on all sorts of monitors. You don't have to know anything about color management to use it. Just install the software that comes with it, plug it into your USB port and follow the instructions. As an added benefit, it's inexpensive compared to some of the other color management tools. It is available on Amazon or on X-Rite's Color Munki Site *www.colormunki.com.*

If you are printing at home, the key is to invest in a good photo printer (I use Epson) and a good monitor with accurate color. You have to take the time to find the best monitor-printer and paper match. Make sure to select the correct options in your print dialog box (paper choice, color and more). It may take some experimentation, but the effort will be worth the time.

FOR THE LOVE OF BOOKS

If scrapbooks aren't your thing and you'd rather create a printed photo book, companies like MPix, Blurb and Apple make printing books of your images so easy. You can print hard cover books straight from Apple's iPhoto and Aperture or upload and create books of your phone's Instagram images with Blurb. Blurb has all kinds of books and various ways that you can go about making a book. You can design it all yourself and upload a complete, finished product or use their web-based downloadable book layout software (an easy drag-and-drop process).

Create books from your trips, make a baby's first year book or compile the images from a school year into a memory book for your child and their classmates. Don't get bogged down in the process and let it thwart your efforts. Use the simple tools that companies like Blurb have to offer and make a book in an afternoon. I speak from experience. As I mentioned when I told you about Project Life, I started scrapbooks for my first two children who are now eight and ten and both of those books remain unfinished in a box upstairs along with a slew of scrapbooking supplies. I do, however, have some Instagram books that I made through Blurb and a few printed photo books that I digitally designed and had printed. The options are all there, you just need to find the method that works best for you.

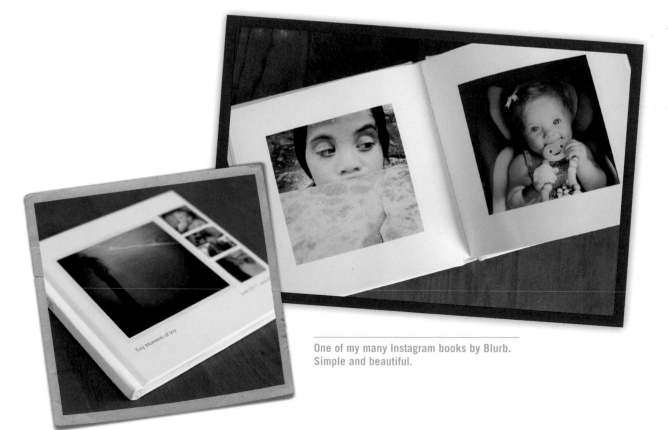

One of my many Instagram books by Blurb.
Simple and beautiful.

WHAT IS WHITE BALANCE?

WHITE BALANCE IS THE SETTING on your camera that controls the color balance in your image. When your image is properly white balanced, the white looks white and all the other colors look natural as well. When your white balance is off, your images will have a color cast to them. They may look greenish or have a blue tint overall. They can appear yellow as well. Different light sources have different colors (also called temperatures). For example, light from an incandescent bulb is red or orange in color. An overcast day will give a bluish tint to an image. Fluorescent lights cast a greenish tint.

Most digital cameras have an auto white balance (AWB) setting. The AWB setting automatically adjusts the white balance when the picture is being taken. The auto setting (which is your camera's default) is not always right. If you see that your image has a funky color tint to it, you might try to use one of the white balance presets. Common presets include daylight, fluorescent light, tungsten light (typical indoor lighting), cloudy skies as well as camera flash. There is also a custom setting, but you likely won't be using that one. Choosing the appropriate white balance preset will help you capture the scene with the most accurate colors.

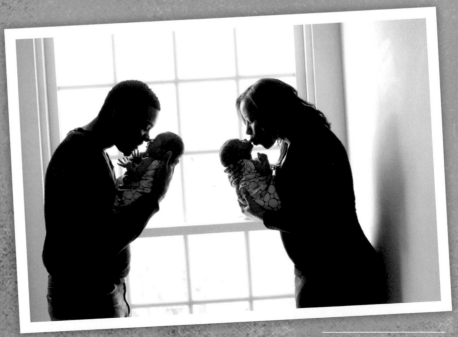

Properly balanced color.

Too green!

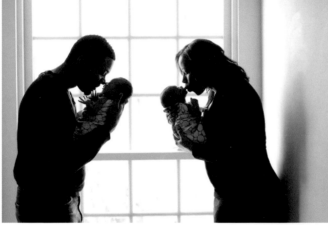

Too pink!

Way too blue!

CHAPTER 14
TheMomentsthat Matter

14

"TAKING PICTURES IS LIKE TIPTOEING INTO THE KITCHEN LATE AT NIGHT AND STEALING OREO COOKIES." – Diane Arbus

No matter how many times it's happened, it always surprises me: I'll be browsing through images looking for something in particular and just stop, frozen. I'll come upon an image of my children that's maybe a handful of years old. The faces are rounder and the legs chubbier. They look like babies instead of kids. It's usually nothing perfect or very remarkable, just an everyday moment, but it takes me back in a flood of memory and allows me to see how far we've come. My children taught me how to be a photographer. Sure, I knew technique from my time spent in art school, but the passion for the moment is something they gave me. So, dear students of mine, as you chase down your own moments that matter, remember this…

THE MOMENTS THAT MATTER ARE...

Unscripted and Authentic.

SOMETIMES OUT OF FOCUS, IMPROPERLY EXPOSED AND **NOT ALWAYS PERFECTLY LIT.**

FLEETING AND MAGICAL.
ONES THAT OFTEN GET BETTER WITH AGE.
MEANINGLESS TO A STRANGER BUT PRICELESS TO YOU.
TINY, NO ONE IMAGE ON THEIR OWN TELLS THE WHOLE STORY.
THE ONES THAT MAKE YOU REMEMBER AND THE ONES THAT SHOW THEM WHAT IT WAS LIKE.
WHAT MAKE CHASING THE MOMENT WORTHWHILE.

HOW TO PRACTICE

- Photography isn't a skill that you learn once and then you're awesome at it. It's a practice. The more you do it, the better you become. Your photography will grow and change over the years. When you feel frustrated with something, come back to this book and work through some of the chapters again.

- Learn your equipment. When you know what the various buttons and dials are for, you will be less intimidated and able to catch the shot faster.

- Go online and watch tutorial videos and check out the bonus content in the *My Book* section of *www.farrahbraniff.com.*

- Use the cheat sheet on the following page to help you memorize the technical info. Go online and download a printable copy of the cheat sheet to leave in your camera bag.

- Find some photo friends and take photo walks in your town. Explore, shoot and create!

- Look around you and see the world in new ways.

- Celebrate your family!

GRATITUDE

To Bright Sky Press: Lucy Chambers, Ellen Cregan and Marla Garcia. Thank you for taking a chance on me. Your help, wisdom and guidance helped this book become so much better than I even thought it could be.

Thank you to my friends. Each of you has, in their own unique way, made this little dream of mine possible. Thank you for making me laugh, encouraging me, believing in my work, sharing your hearts, being patient and accepting me as I am: Rachel Allen, Rhett and Emily Braniff, Rob and Alyssa Brakey, Brené Brown, Julia Burke, Danny Clark, Wendy Coones, Jeanice Davis, Sarah Ellenzweig, Jenny Johnson, Cricket and John Krug, Kristen Matelske, Jamie Milward and Karen Walrond.

For all of my art teachers: I cannot imagine what the course of my life would look like without art. David Sheard, Eileen Montgomery, Rix Jennings, John Halaka, Joe Vitone and Linda Connor. You all taught me the importance of being purposeful about my art and let me see that being an artist (for a living) was possible.

To all of my clients and friends who shared themselves and their beautiful children with me as I built my business and found myself as a children's photographer. Some of you have been with me since the very beginning of this journey. Thank you for trusting your family's memories with me. Your children's bright and shining faces make this book come to life.

To all of my students. Your questions, confused faces, "aha!" moments and enthusiasm for photography guided everything that I wrote on these pages.

CheatSheet

light meter

-2	-1	0	+1	+2

underexposed (too dark) just right! overexposed (too light)

iso

100 200 400 800 1600 3200 6400

lowest light sensitivity for daylight highest light sensitivity for nighttime

f-stop

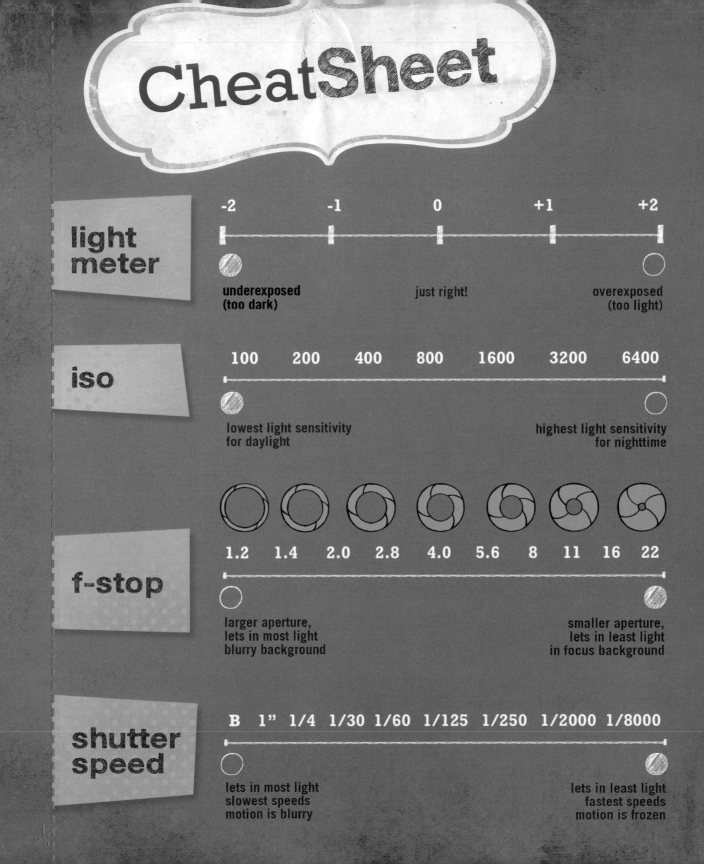

1.2 1.4 2.0 2.8 4.0 5.6 8 11 16 22

larger aperture, lets in most light blurry background smaller aperture, lets in least light in focus background

shutter speed

B 1" 1/4 1/30 1/60 1/125 1/250 1/2000 1/8000

lets in most light slowest speeds motion is blurry lets in least light fastest speeds motion is frozen

10 TIPS FOR BETTER PHOTOS

1. **Tell A Story.**
 Ask yourself *What is the story I am trying to tell?* Let that question guide your choices. How close will you get? Which lens will you use? Are you freezing motion or blurring out a background?

2. **Keep it Simple.**
 Try to clean up your backgrounds and foregrounds and keep your images simple. Only include what is necessary for telling the story.

3. **Get Closer.**
 Zoom in or move yourself in closer to what you are photographing. This helps simplify and even soften your background. Make it clear what the main subject is and don't let background distractions confuse your composition.

4. **Look for the Light.**
 Learn where the brightest spots are in your house and try to photograph there. Pay attention to where the sun is and find the best light that you can.

5. **Learn your Camera.**
 Know where the controls are and how to adjust your f-stop, shutter speed and ISO. Learn how to adjust your auto focus points and practice so that your hand can move to the controls that you need quickly.

6. **Be Purposeful.**
 Shoot with intention and mindfulness. Experiment with framing, notice your foreground and background and challenge yourself to see the subtle beauty all around you.

7. **Chase Authenticity.**
 Say no to fake smiles, too much posing or the dreaded "say cheese!" Practice capturing your loved ones in all of their candid glory.

8. **Take at Least One Picture Every Day.**
 Every picture that you take makes you that much better. Obsess! Use your cell phone when you don't have your big camera but keep your eyes open and your photographer's eye turned on.

9. **Play and Experiment.**
 Take pictures of things that you normally wouldn't. Find the beauty in the everyday things all around you.

10. **Be Patient with Yourself.**
 Photographers are not made in a day. Practice, push past your mistakes and stumbles and keep going. Photography is a journey and this is only the beginning.